Pursuing Christ. Creating Art.

Exploring Life at the Intersection of Faith and Creativity

Gary A. Molander

WESTBOW
PRESS
A DIVISION OF THOMAS NELSON

WestBow Press books may be ordered through booksellers or by contacting:

WestBow Press
A Division of Thomas Nelson
1663 Liberty Drive
Bloomington, IN 47403
www.westbowpress.com
1-(866) 928-1240

Because of the dynamic nature of the Internet, any web addresses or links contained in this book may have changed since publication and may no longer be valid. The views expressed in this work are solely those of the author and do not necessarily reflect the views of the publisher, and the publisher hereby disclaims any responsibility for them.

Any people depicted in stock imagery provided by Thinkstock are models, and such images are being used for illustrative purposes only.

Certain stock imagery © Thinkstock.

ISBN: 978-1-4497-1801-5 (sc)
ISBN: 978-1-4497-1803-9 (hc)
ISBN: 978-1-4497-1802-2 (e)

Library of Congress Control Number: 2011929739

Printed in the United States of America

WestBow Press rev. date: 06/23/2011

For Angela, Lindsey, Allison, and Sydney

Contents

ACKNOWLEDGMENTS

To the beautiful congregations at Clovis EV Free Church, Fresno First Baptist Church, and Celebration Christian Fellowship - This book would be a series of blank pages without you.

To Pastors Steve, Ray, Woody, Willie, and Joe - Thank you for giving me a place to learn and to grow.

To Nick - Thank you for your enduring friendship over these past 30 years. You sustain me. Real tomato ketchup, Eddie?

To Craig - Thank you for being a great brother, and for creating music alongside me during the days of Deliverance. Those days formed me for exactly what I'm doing now.

To Marty - Thank you for showing me how valuable a music ministry volunteer can be. Thank you for always helping me to see clearly.

To Andy and Sherene - Thank you for loving me enough to allow me to take off my "pastoral hat", and to simply be normal. Thanks for the road trips, and for RV dump sites in Modesto, CA.

To Bob and Peggy Molander - Thank you for bringing me into this world, and for fostering the creative spirit in me. And thank you for running to embrace me when this prodigal drifted far away. I cannot wait for the day when I run to embrace you.

To Angela - Thank you for believing in me enough to ride the rapids of pastoral ministry, seminary, and job changes. Thank you for being the best Mom on the planet, and for continuing to function as the spouse with the steady job. I am well aware that I married up.

FORWARD

This book is not about how to paint better. But you'll probably paint better.

This book is not about how to write better. But you'll probably write better.

This book is not about how to pursue Christ with more zeal. But you'll probably pursue Christ with more zeal.

This book is not written as a how-to book at all. It's written as a series of Jesus-based explorations, at an amazing and confusing and beautiful and insane intersection.

If you were to draw a circle, and write the words "pursuing Christ" inside of the circle...

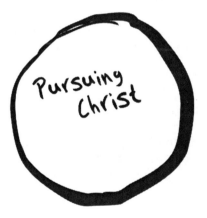

Then, if you were to draw another circle, and make it overlap the first circle on one of the edges.

And inside of that new circle, you were to write the words "creating art"...

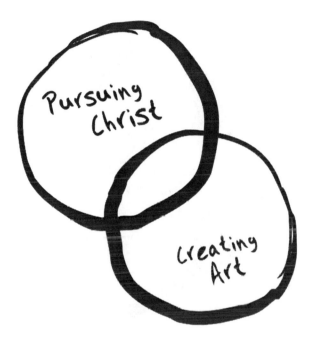

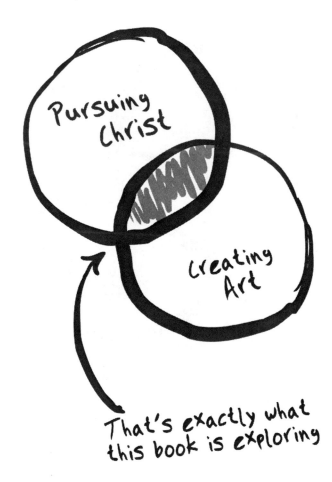

Pursuing Christ

Creating Art

That's exactly what this book is exploring

Me

I'm Gary.

Gary isn't a very popular name these days. Sometimes you see a really adorable newborn baby in Target, and you look at the parents...

INTRODUCTION

...and say, "Oh what an adorable baby. What's his name?" When this happens, you probably won't ever hear either of the parents say, "Oh thanks. His name is Gary."

And when they write my name on the cup at the coffee shop, I'm fairly confident that the barista girl turns around to get the coffee, and secretly lets out an I'm-sorry-for-him sigh, as if to say, "I guess that was a popular name in the 60's."

It wasn't.

I say this only by way of introduction.

I'm writing with the assumption that you may not know who I am. Most authors who take on a writing endeavor like this have already experienced some measure of popularity, usually on a large stage. And while my wife thinks I'm pretty special, and my girls think I'm funny, I think you might not know who I am.

I need to tell you that I feel really good about the man I'm becoming - maybe for the first time in my life. I feel really good about writing this book for you to read. And I feel really good about being a child of God.

I don't think I'm prideful. I think I'm naively confident. I think that, if you took ignorance and mixed it with big dreams, I'd be somewhere stuck to the sides of that blender. Then, if you added just enough leadership to see a couple of days into the future, you'd really experience the person I am.

So to help you understand the place I'm writing from, there's a section at the beginning of this book to help you do that. Feel free to skip this Section. Don't feel guilty if you skip this Section.

I'd probably skip this Section.

PASTOR

I was a full-time pastor for seventeen years. The kind of pastor where the church pays your salary, where you marry people and bury people, and

where you're always on call. I completed Hope International University's Master's program, where I received a Masters of Arts in 2004.

As you read any book or blog or journal, it's important to remember that any author is always reacting to something. The same is true of this book. Much of what I'm writing about is a reaction to being a pastor for so many years.

There's good stuff.

There's bad stuff.

And for the rest of my life on earth, I'll be reacting to both.

I think the most difficult job in the entire world is being a mom. I think the second most difficult job in the world is being a pastor.

I think pastors are under more spiritual attack than any other group of people I know.

I think pastors want to create heaven, but need pieces of hell to get there.

I think pastors put far too much pressure on themselves.

I think pastor's families should be off limits to the constant critique of church whiners, and I think there should be a Board or Committee established to escort chronic whiners to the exit doors. Quickly.

I think pastors should love God and people more than anything, and I think they should work endlessly at creating environments where Kingdom grace is experienced.

I think pastors should stop copying each other.

I think many pastors have confused being a pastor with being an entrepreneur. And I think the people in their care already know that. The acid test is love. It always is.

I think pastors have the best Story in the world to tell, so the best pastors are the best storytellers.

I think the best pastors are also the best lovers. Not that kind.

I think pastors are artists who might not really believe that.

I think pastors provide a covering for their people. I think they shepherd us.

I think it's really good that I'm not a pastor anymore, because I can't live up to that list.

MY FIRST TIME

I was thirty-six when someone first called me an "artist". Until then, I was a musician, or a worship pastor, or a tall man. But never an artist.

The church I served had asked a church growth consultant to spend the weekend with us. All healthy things grow, and our church wasn't growing. So we probably weren't healthy. Our hope was for this pastoral veteran to come in, tell us what we were doing wrong, and help us fix it.

After a weekend of meetings and consultation, his findings were simple. We needed to become more like the mega-church he served. He believed that would make us healthy. We believed it, too.

We needed to turn up the music, stop serving so much coffee, kill the drama program, and have people read their testimonies in every worship service. He suggested we adapt his strategy for our church, and even proclaim his church's mission statement as ours. With a few tweaks.

We were stoked. We did everything he suggested.

For two years.

And nothing changed.

Copying someone else's success story isn't always the best way to create your own.

I felt demoralized and empty. I had changed so much in the ways I carried out my weekly responsibilities, and our church wasn't growing. I wondered if it was my fault.

I always wonder that.

Our Lead Pastor and I ended up at something called "The Willow Creek Arts Conference". I think we just stumbled onto it, primarily because they came to California that year, and we only had a few hours to drive. So we attended the Conference. Just the two of us.

After the first day, my pastor and I loved what we were experiencing. The deepest part of our hearts were being ministered to. This Conference was going far beyond tips and techniques, and into the deepest recesses of our souls. I'm not a crier, but I'm pretty sure I ugly-cried during that week.

My pastor and I were engaged in the typical after-the-session discussion at lunch. Entirely unaware that there was food in his teeth, I'll never forget what he asked me.

"Gary. If we're going to remain stuck as a church, then why don't we trash our current strategy, and start doing what we really want to? If we're going down in flames anyway, let's enjoy ourselves."

When he said that, something exploded in my heart. I knew he was right, and I was excited about returning to our core desires, and leading from there.

We flossed, then went back in to the Conference. The afternoon session started with someone I had never heard of named Nancy Beach.

Every single word from Nancy's mouth landed directly on me. It was like God had already told her about my deepest passions and desires, and she was simply relaying that knowledge to me.

She described the character traits of an artist. Until then, I thought an artist was only a painter. She helped me see that my core personality was artistic, and that I needed to embrace that.

I was changed. For good.

From that day forward, I've lived with the "artist" label as a key defining point for my own self-understanding. Everything I do, and every odd way I behave, can be expressed by simply saying...

"He's an artist."

And I'm good with that.

CRASH AND BURN

Just after I earned my Masters in pastoral ministry and creative arts, I crashed. It was the Fall of 2004.

It was the best thing that ever happened to me.

Three years before my crash, I was driving a 1985 Winnebago home from Yellowstone National Park. The RV line was called the "Minnie Winnie", and every time I say that name out loud, the seventh-grade boy inside of me giggles. My friend Pat always reminds me that you can take the boy out of the seventh grade, but you can't take the seventh grade out of the boy. I think he's right.

As I was driving home with my family, under the immeasurably vast Montana sky, God began to whisper something into my heart that felt like these words: "You are not cut out to remain a pastor any longer."

I pretended it never happened.

Up until that point, I had been a full-time, licensed, marry and bury, lead worship and preach pastor for fourteen very full-time years. But secretly, I was dreaming of life as a normal person. I thought those dreams were Satan attacking me.

I didn't realize that they were God inviting me.

Admitting my feelings to anyone would be admitting failure, so I pressed on in pastoral ministry for another three years. I persevered with some measure of success, until the Rams played the Steelers on Monday Night Football, in November 2004.

My Rams were losing that night, and it put me in an awful mood. Sports fans are stupid that way, and I am the king of stupid. They should have never released Warner. My awful mood carried into a garage cleanliness discussion with my wife – a discussion that eventually elevated to knock-down, drag-out proportions. My three daughters hid in their rooms while Dad spewed verbal wildfire all over the house.

I had become the man I promised never to become.

My kids knew it. My wife knew it. And finally, I knew it. The next morning, I met with the Lead Pastor of my church and resigned. I didn't just resign from that church. I resigned from Pastor Gary.

Two months after that meeting, I found myself without any job, and living on the single salary of my wife. But most of all, I found myself in the middle of a complete identity crisis. I had been a full-time pastor for seventeen years. And now, if I was no longer a pastor, who was I? Through an emotional and unintended journey, I discovered me.

I discovered that I never wanted to be paid by a church again. I discovered that I love being a dad, and that I had a lot of making up to do. I discovered that I am a risk-taker, and an entrepreneur. I discovered that I love to preach, but with film and written words, not spoken ones. I discovered that Jesus' message is an invitation to a Kingdom, not an invitation to a new legalism. I discovered that I needed to reacquaint myself with God's grace, and that I needed to model, and live into a Kingdom-grace in all of my relationships. And finally, I discovered that I was a terrible employee, and that I needed to lead within a team of people who trust me, and I them.

I formed a production company called Floodgate Productions. We create short-films for the Church. Later, I formed the Floodgate Foundation - a non-profit organization that funds community restoration projects in El Salvador.

My wife has come alive since then, and my daughters have learned to trust me again. The women who live under my roof give me more life than I can bear. We laugh more than ever. We eat dinner together every night.

Just after I earned my Masters in pastoral ministry and creative arts, I crashed. It was the Fall of 2004.

It was the best thing that ever happened to me.

And I'm still a Rams fan.

CONFESSION

I am an artist.

I experience higher highs than non-artists. I throw parties when an ingrown toenail experiences healing.

I experience lower lows than non-artists. I can lie helpless in the fetal position when I experience an ingrown toenail.

I live in heaven or hell. There is no Hades.

I am deeply introspective and overly self-critical.

I want you tell me the truth about my art.

I wish you wouldn't tell me the truth about my art.

I live one-step on the other side of the line, and stick my big toe over with too much regularity.

I need authority, and I struggle with authority. And I don't really think I need authority.

I have a much better way, and I have no idea what that is.

I am naturally unorganized, but I've forced myself to become more organized. I've done this in the name of self-preservation.

I love Jesus with all my heart and all my soul.

I honestly believe that beautiful art can change the world.

I can't wait to create some new thing.

Thanks for listening. I feel better now.

I LEAD FROM THE MIDDLE

There are people in my life who tell me that I'm a leader. I think it's funny for me to label myself as that. I don't think Jesus ever called himself a leader, so it's a good idea for me to refrain from that title too.

People tell me that, when I lead, I do so from the middle. Many people lead from the front. They're out in front of everyone shouting, "This way. Let's go."

I'm not like that. I'm in the middle, asking those around me, "Should we go this way? I think we should. What do you guys think?" More importantly, I want to make sure there are good places to eat along the way.

A friend of mine named Bub once said this about me: "Gary leads you, and you don't even know you're being led." I think that was a compliment. And I think Bub is a better name than Gary.

Another friend of mine tells me that I'm good at connecting the day-to-day dots, so that she can see the larger picture that's being created. I think that was a compliment, too.

I think the best leaders help unearth the dreams and desires of the people around them. Then, I think those leaders establish an environment for their people to function out of those dreams and desires.

The best leaders in my life have always proven to me that I'm loved by them, more than they love any task I could perform for them.

HOW TO READ THIS BOOK

There are several different ways to use this book in your life.

You could read through it as fast as possible because your boss bought you a copy and is forcing the issue, and because he told you that he wants to discuss it as a staff on Wednesday, and now it's Tuesday. If you're using this method, I would use a yellow highlighter a lot. I would also underline sentences with a red ink pen. Finally, I would write "Yes!" and "Disagree" in the margins of every eighth article on some pages. During the book discussion with your boss, I would angle the book so that your boss can see how much you've chosen to dig deeply into this book.

You could read one or two articles at a time, and just take your time. At the end of every reading, you could ask yourself some questions:

- Is he talking to me?

- Is God talking to me?

- What should I do about this now?

- What art should I be creating for the world?

- Who do I need to love better?

You could post quotes from the book to Facebook and Twitter, then process it with your friends and followers.

You could take ideas and quotes, and write your own blogposts about them. You can agree, expand, disagree, or whatever you want. Just be nice. My friend Pat says that artists serve people better when they play nicely together.

Purpose

When I was in high school, my view of art was somewhat limited. First, my personal tastes were focused on comic books and elaborate graffiti. But more important, I was unaware of...

INTRODUCTION TO PURPOSE

Written by Scott McClellan

...the relationship between art and originality. I was content to reproduce what I saw, either by copying or outright tracing. So to the extent that I've moved beyond tracing in my personal artistic pursuits, I owe a huge debt of gratitude to the art teacher who offered me and my classmates a history lesson.

For centuries, paintings' great contribution to society was the practice of painstakingly depicting historical figures and events. A painter was generally valued to the degree that he could produce accurate and compelling recreations of monarchs, cities, landscapes, battles, and so on. The artist's usefulness was tied to his ability to imitate real life with oil on canvas.

And then came photography.

Believe it or not, with the advent of the camera, many assumed painting would become obsolete. Just as some new Smart Phones are heralded as iPhone killers, the camera was the Painting killer. After all, photography is better suited than painting at capturing images of people and places. Even 150 years ago, a photograph was (or was on the verge of becoming) more accurate, more efficient, and more reliable than a painting.

The abacus was about to be replaced by the adding machine. The carriage was about to be replaced by the automobile. Folgers was about to be replaced by Starbucks.

And that's what happened. Photography killed painting. We don't sit for days and weeks as a paint-stained artisan toils in front of canvas. We book a 30-minute session with a photographer.

And yet, painting lives on. How? Why? Perhaps we can find a parallel in the Christian experience.

We believe Scripture is the inspired Word of God, and the Church has been guided by this sacred text for centuries. But even though the Bible is a closed canon, Christians can't seem to do enough writing. Even though we have the spoken words of Jesus in the Gospels, Christians can't seem to do enough speaking. Even though the Bible gives us pages of psalms and poetry and drama, Christians can't seem to do enough creating.

What's the point of all this Christian creation? What's the point of picking up a paintbrush when you could pick up a camera?

The answer, I think, lies in who we were created to be.

And the one who created us.

BIG ART

When most people hear the term "artist", they most often translate it as "painter". At least in their minds. I think being an artist is so much more than that.

An artist is a heart condition, not a job.

And there are many different vehicles that carry the heart of an artist.

Painters.

Sculptors.

Graphic Designers.

Filmmakers.

Set Designers.

Actors.

Storytellers.

Authors.

Musical Worship Leaders.

Visual Worship Leaders.

Web Designers.

Bloggers.

Musicians.

Song Writers.

Singers.

Photographers.

Poets.

Sketchers.

Dancers.

Mimes.

Yes - mimes.

Font creators.

Chefs.

Videographers.

I've probably left something out. But I want you to read that list so that you'll see how much bigger an artist is than we normal consider him to be. I also pray that you find yourself somewhere on that list, or that you find yourself wanting to be found somewhere on that list.

Being an artist is a heart condition, not a job. I know I'm repeating myself, but it's true. And the vehicle you use to beautifully carry the already-predisposed heart that He's created in you becomes your art. These are the vehicles listed above. You are not these vehicles - it's just that your heart's expression has found a home there.

So if you think you're not an artist, that may be true. But chances are, you picked up this book for a reason. And if I were a betting man, I'd say you picked it up because you're already bent in the artistic direction, whether or not you've ever created anything famous.

When I was a youth pastor, I served at the Clovis Evangelical Free Church for eight years. Those eight years were great for me. During that time, there was a man named Art who came to faith in Jesus Christ, responding to God's initiative love invitation. Art was a really big man. All of us began to call him Big Art.

Big Art.

As you read, please intentionally make the term "artists" bigger than you think.

Because it is.

CREATIVES VS. ARTISTS

My wife does not consider herself to be creative. During her days, she works full-time as a Special Education Teacher. It's her job to take the curriculum that the State of California mandates, and turn it into something that a group of K-thru-2nd grade children will be able to learn.

My wife does not consider herself to be creative.

During her late afternoons and early evenings, she figures out how to get our three daughters to the doctor, the dentist, the orthodontist, the school event, the midweek church youth program, the volleyball practice, and the drama rehearsal. And somewhere in the middle, she makes dinner happen. Dinner for five.

My wife does not consider herself to be creative.

Despite all the evidence to the contrary, if you ask my wife about her creativity, she'll tell you that her husband is the creative one. She'll tell you that her husband is the one who designs stuff, creates films, writes, and plays music.

She, along with millions of other people, have equated being creative with being an artist. She doesn't paint, so she's not creative.

And many artists I meet are unknowingly perpetuating the myth.

Theologically speaking, everyone is creative. We were fashioned and formed in the image of God. God is a creative God. So we're creative too. We bear the divine imprint. Our Maker is creative, therefore we are creative.

With God, there is a void, and He fills it with himself. If you read Genesis Chapter 1, you'll see what I mean. For God to be creative, He fills a void with Himself. The creation account speaks to this - it's called the "creation" account for a reason. The law and the prophets attest. Jesus becomes the ultimate fulfillment of God's void-filling activity, and His Spirit fills the void every day in our hearts and minds and souls and guts.

Creativity, in the Divine sense, is when we see a void, then fill it with ourselves.

A minority of us are filling that void with our art – our words, our clay, our paint, our 3-D effects. If you have the ability to fill a void with your art, then you're an artist. Lucky you.

But others fill these voids by adapting curriculum so that children with disabilities have a fair chance at living long and full lives.

For years, I've drawn a line between those who are creative, and those who are not. And the line I've used is art. I've used the term "Creatives" over and over again, describing artists.

The line I've drawn is unintended, but entirely non-biblical. It's not even close to God's understanding of what it truly means to be creative.

We artists really need to be careful – for when we make creativity and art the same thing, we de-humanize another human made in the image of God. By our misunderstanding of creativity, we build up our tribe, while tearing down people like my wife.

Does an artist need to be creative? Yes.

But does a Creative need to be an artist?

Absolutely not.

THE PURPOSE OF ART

Why does art exist?

You'll undoubtedly find infinite opinions and commentary on the topic. You can probably think of your own unique purpose for the art you create. And it would most likely be a good reason for art to exist.

In my opinion, art finds its truest purpose when its creator attempts to make visible the invisible.

Love is an invisible concept. So is patience. So is forgiveness. In its purest form, art enables people to see love, to see patience, and to see forgiveness.

The Christian artist then, takes that primary purpose, and adds one word to it.

God.

The artist who also fears God expresses arts' truest purpose when she attempts to make visible the invisible God. And that's really what we're doing in our art.

We're making visible the invisible God.

God's beauty is something that's difficult to define, but it's something we can point to in our art. We can point to grace, and to love, and to forgiveness. In our art, we can point to His wrath, or His discipline. In art, we can proclaim, "There's God. Over there. Take a look." His mystery isn't stripped or lessened.

It's proclaimed.

God's mercy can be made visible in our stories. His beauty can be showboated in our watercolors. His desire for brokenness can be sung in our songs. And something that was invisible is now made visible, even if it's just a shot in the dark at such a vast and holy mystery.

INITIATIVE AND RESPONSE

Christian artists don't need to create art for God. They need to create art in response to God.

The artist's work is a creative work of response, not a laborious work of initiation. The artist's primary task is to respond. God in Christ, working through the beauty and pain in the lives of artists, beckons them to respond to that working, and to simply and beautifully create.

Our paintings, and our songs, and our web designs, and our short films, and our blogs, and our poems, and our acting, and our public storytelling, and our motion loops, and our photography, and our script writing, and our editing, and our sketching, and our dancing, and our set designs, and our screenplays.

All are a response to something previously given to us.

> *"We love because He first loved us."*
>
> (1 John 4:19 NIV)

He did something first, and we are now able to go and do something that looks and smells a lot like what He's already given to us.

We create art because He first created art.

And the art He first created is you. It's me. It's anyone who has been made alive with Christ.

And once that redemptive act has taken place - once that grace has done its saving - we respond in *"...good works, which God prepared in advance for us to do"* (Eph. 2:10 NIV).

And for artists, our good works become the lives we live, which cannot help but include the art we create.

You don't need to create art for God. He doesn't need it. You need to create art in response to God.

Because the world needs it.

FOR THE WORLD

Christians don't need to create art for God. He doesn't need it. Christians need to create art in response to God.

Because the world needs it.

The world needs art. The world needs your art. It doesn't matter if it meets your own expectations. It won't.

The Psalmist provides one of the most beautiful artistic musings available anywhere.

> *"He put a new song in my mouth, a hymn of praise to our God.*
> *Many will see and fear and put their trust in the LORD."*
>
> (Psalm 40:3 NIV)

The entire first portion of this Psalm is about God rescuing David. You can almost hear Bono's vocals, soaring above that easily recognizable bass run.

> *"I waited patiently for the Lord. He inclined and heard my cry.*
> *He lifted me up out of the pit; out of the mire and clay."*
>
> (Psalm 40:1-2 NIV)

Then in verse three, David begins to word-paint what God did, and why He did it.

HE PUT

God initiated something. He put. He placed. He started. He always does that. We don't put. God puts.

A NEW SONG

Music was a dominant art form among David's culture. This artist is given a song that's fresh and creative. He hasn't possessed its melody yet. He's not giving an old song a new feel. It's new.

Have you ever considered that music may potentially be the most powerful art form in existence, because a good song never leaves our memory? When was the last time you left church humming the third sermon point?

IN MY MOUTH

David's job was to respond to the gift that God gave him. For David, his response was singing. He didn't put a new song in David's bulletin outline. He put it in a place that demanded some response from David. He wanted him to sing it. So David sang.

A HYMN OF PRAISE TO OUR GOD

David has been given something, and His response is a piece of art (music) that glorifies God.

David's response to God is art. Art that glorifies God. But not because God is an insecure teenager who needs His fragile self-esteem built up by telling Him how good His new pants fit.

God doesn't need our glory just to hear us say it.

MANY WILL SEE AND FEAR

All the people who know of David will see his life's response to God. They'll view the art he's creating, the song he's singing, and the praise he's displaying.

AND PUT THEIR TRUST IN THE LORD

There it is. The goal of art. The goal of redemption. Trusting intimacy, wrapped in a sacred and holy reverence for God.

That's gorgeous, and more brilliant than any man could possibly invent.

So the answer to your question is yes. Of course I'm reading into this passage. I'm an artist bringing my own interpretation to shed light on what it might possibly mean. And of course I came to this verse with assumptions. We all bring assumptions to Scripture. I might be reading into it too much.

But I might not.

What's abundantly clear is the intricate relationship between God's saving work, a piece of art that's created in response to that saving, and a world that's invited to interpret that new piece.

I think that's how it's designed to work. God saves, redeems, and resurrects. Artists respond to that work with art. And a world of onlookers looks on. Because at the heart of it all...

Art is missional.

The point of art is to make visible the invisible God, for the world to see.

Christians don't need to create art for God - He doesn't need it.

Christians need to create art in response to God - Because the world needs it.

Identity

I've spent a good chunk of my life never very certain of who I am. Allow me to explain...

I lived my life, until the age of around 8 or 9, in what I viewed as a pretty loving home with...

INTRODUCTION TO IDENTITY

Written by Jason W. Rowe

...my mom and dad and sister and cocker spaniel and birds. Two birds. I saw myself as a fairly normal kid, living a fairly normal life. And it was around this normal time in my life that everything changed.

My parents sat us down and explained that things weren't "working" anymore, and that they were going to separate for a while. That turned into a couple years, which turned into a divorce, which turned into me having a more distant father, which turned into me having an absent father.

I went from seeing myself as a "normal kid" to a "fatherless kid" in the span of a few years.

I remember thinking that I would never really get to be a man because there was no one to teach me how to do man stuff anymore. So at the ripe old age of twelve or thirteen, I decided I should take my identity and my "man-ness" into my own hands. So I did what I thought all men were supposed to do.

I became more aggressive. I cussed. I talked about girls. You know - man stuff.

Thankfully, we moved to Fresno when I was fifteen years old. I began to form a father/son type relationship with my grandfather. I began to gain a better grasp on the type of man I should be - how a real man should act. Best of all I began to discover how a man seeking to be in communion with God should act. I really began figuring out who I was, who I could become, and who I thought God had made me. I discovered my identity through my relationship with my grandfather.

I thought I had a handle on the future and who I was becoming. Kinda felt like I was learning my place in this world (go ahead... start singing some early 90's Michael W. Smith).

But in September of 2001, my grandfather died. My role model, my compass for true North, suddenly passed away. That single event was easily the most devastating moment of my life. Where would I look for advice? Who would I turn to? How would I continue to be the man I was suppose to be? Once again, I was fatherless.

And angry.

I poured myself into my current romantic relationship, mostly because it was the only thing I felt held security for me. I began shaping my identity around the girl that I was dating. I spent all my time with her. I focused my decisions around what I thought she'd say or think. I built my identity on being a boyfriend. After all, she'd mentioned marriage more than once, so I was pretty sure we'd always be together. Safe assumption on my part, right? Nope.

That relationship disappeared quickly.

So I started building myself up around being the primary worship leader for the Sunday night worship service for my church. I needed something solid I could lean on and identify myself with. This worked, until the Leadership of the church canceled the service to head in another direction.

All of the people and things I placed my identity in kept disappearing. One after another they either left, or they were taken from me - either through decision, tragedy or conflict. How was I supposed to know who I was, when everything I felt gave me value kept going away?

As artists who are Christians, we must discover how to gain our identities outside of our circumstances. We need to separate ourselves - as difficult as it may be - from the things that happen to us. We need to learn to build the foundation of our identities on the Unwavering - on the only thing that matters. Because people will leave, opinions will change, and circumstances will vary. The only constant is God.

The God was, who is, and who always will be.

FATHER AND CHILD

In Scripture, names matter. Names are more than titles. They're personality descriptions. They inform core identities.

Gary literally means "the hunting dog". In Scripture, my friends would automatically assume that I'm a hunter with mad skills, and that I spend much of my time stalking, capturing, and killing. People who didn't know me - people like the Assyrians - may have heard crazy rumors about other people who had messed with me, and wished they wouldn't have.

BEFORE JESUS

When people in the Old Testament talked about God, they were extremely careful about what they called Him, and how they referred to Him. Because God's name ascribed His character. His name described His identity.

Do you remember when God was trying to convince Moses to go back into Egypt, confront Pharaoh, and free all of Israel from the bondage of slavery? During that conversation, Moses had a legitimate question for God.

> *"Suppose I go to the Israelites and say to them, 'The God of your fathers has sent me to you,' and they ask me, 'What is his name?' Then what shall I tell them?"*

(Ex. 3:13 NIV)

Good question. And God's answer is pretty cool. I can almost hear it thundering down on poor Moses (who was halfway asking a real question, and halfway excusing himself from the difficulty of the task).

> *"I AM WHO I AM. This is what you are to say to the Israelites: I AM has sent me to you."*

(Ex. 3:14 NIV)

You should read the whole conversation for yourself.

That's God's name for Himself. I AM. It describes Someone who is entirely eternal. I see it used over and over with a special focus on His patience and lovingkindness.

The names for God, used by people who were living before the cross of Christ, were very limited.

Especially the name Father.

God is called Father in the Old Testament a grand total of six times. And every time He's called that, it's a formal title (like "Father of Nations", or "Father of Israel", or something like that). It was a title.

DURING JESUS

Fast-forward a couple thousand years, to when Jesus comes on the scene. He's a peasant, probably a little smelly, and not too easy on the eyes. And He starts calling God Father.

Literally Daddy.

As you might imagine, the religious leaders aren't thrilled.

The religious leaders of Jesus' day get a bad rap, in my opinion. We have to remember that so much of what they objected to in Christ's actions and beliefs were simply their response to the Old Testament Scriptures. Even though they were a bit arrogant, they were doing what they thought was right. They weren't just outright jerks. Mostly.

In John Chapter 8, Jesus almost gets killed because He tells the religious leaders that God is His Dad, but not theirs. You should read it for yourself. The name Jesus gives to their father is funny. And scary.

Two chapters later, Jesus makes the amazing claim that He and His Dad are one. And just like before, Christ's opponents pick up stones.

I think I would have picked up stones to kill Jesus, too. I think the hunting dog part of me would rise up, and would want to kill everything that's threatening that which I'd been taught to protect. God's name is sacred, after all.

AFTER JESUS

Fast-forward a few more years. The crucifixion. The resurrection. The birth of the Church. The expansion of the Church.

Rome.

There appears a church plant in Rome, and Paul is writing a letter to the people there. Historians believe that there were community mailers sent out to a targeted list. And in a beautiful and logical treatise, Paul helps the Christians in Rome see where they were, how Jesus met them there, and where they are after that meeting.

Now is not a place where life is easier.

Now is not a place where life is safer.

Now is place where life is resurrected, in the middle of the chaos.

> *"But if Christ is in you, then even though your body is subject to death because of sin, the Spirit gives life because of righteousness."*
>
> (Rom. 8:10 NIV)

The Roman Christians were dead. But not anymore. They were made alive in Christ. Just as Christ died and was raised again, so are they now resurrected to new life. Something that was not breathing is now experiencing full oxygen, pushing Divine life into every cavity of their souls. And once this resurrection has taken place, Paul makes a claim that would once again force religious leaders to pick up stones.

> *"For those who are led by the Spirit of God are the children of God. The Spirit you received does not make you slaves, so that you live in fear again; rather, the Spirit you received brought about your adoption to sonship. And by him we cry, "Abba, Father." The Spirit himself testifies with our spirit that we are God's children."*
>
> (Rom. 8:14-16 NIV)

And by Jesus, we cry out a name - a title we're urged to call God.

Father.

The very same name Jesus referred to when speaking of the Old Testament I AM, is now used by Paul and by the Christians in Rome.

And by us.

And the only way we can legitimately call God Father comes from the fact that we have become sons. And daughters. You don't call someone Father unless you're a son or a daughter. You don't call someone Father if you're still a slave to them.

We are children of God.

We are children of God who happen to be artists.

Never get that turned around.

YOU ARE NOT YOUR MINISTRY

Identity is the person you are, regardless of your actions. Take your actions away – both good and bad – and whatever is left is your identity. And there's only one identity that has any value.

A child of God.

Every other identity you could grab onto pales in comparison to being, in the deepest part of your heart, a child of God. And so it makes perfect sense that your core identity will also house your strongest temptation – your greatest lure. When our Enemy attacks, his striking point will always be to our core.

To our identity.

Unfortunately, for people in any church ministry, his exact point of strike is the temptation to confuse our ministry with our identity. He wants to make them the same.

They are not the same.

When I pastored in a church, I made this mistake. I allowed my job to become my identity. I suffered through this mistake, until the day I resigned. Because when I stopped being a pastor, the false identity I had created was also stripped away. The next morning I woke up and cried uncontrollably on the living room floor. It was that gross, snot-streaming, can't breathe crying – the kind where my wife wondered if she should call 911. My main question was this: "If I'm no longer a pastor, then what am I?"

Finally God had me right where He wanted me. Now, the rebuilding process could begin.

Here's what I know about you.

I know that you are not your art.

I know that you are not your church.

You are not your tech.

You are not your voice.

You are not what your authority figures believe about you.

You are not your blog posts, or your readers' insane responses.

You are not your Twitter count, or your Facebook friend total.

You are not your impact.

You are not your successes, and you are not your failures.

You are not that thing in your life that didn't work out.

You are not that thing in your life that worked perfectly.

I also know this about you. I know that in Christ, you are a child of God. I know that this is your core identity, and I know that your core identity is something that can never be stripped away.

Because there will come a day when you no longer create art.

There will come a day when the software you use is no longer in existence.

There will come a day when you no longer serve in that church, in that ministry.

There will come a day when he's no longer your boss, and they're no longer your Board.

There will come a day when you quit blogging.

There will even come a day when your impact wanes.

But there will never, ever come a day when you stop being a child of God.

Ever.

A TREASURE IN A FIELD

The parables of Jesus are interesting. It seems like these word pictures are given to us so that we can understand something called "The Kingdom of Heaven". Maybe this is because there are no words that can describe this realm.

Only parables.

You won't find any analytical dictionary definition of Christ's Kingdom coming from the lips of Jesus. He talks mostly of location and quality, but He hesitates to define it. Rather, He gives stories that invite us in for a peek.

If you're familiar with the Bible, you're probably familiar with the parable of The Treasure in the Field. If you're not familiar with that story, it goes like this.

> *"The kingdom of heaven is like treasure hidden in a field.*
> *When a man found It, he hid it again, and then in his joy*
> *went and sold all he had and bought that field."*
>
> *(Matt. 13:43-44 NIV)*

A guy finds a treasure that's been hidden in a field. So, like a ten year-old boy who's full of joy (and who concurrently thinks he might be in trouble) quickly buries the treasure again. He runs out, sells everything he has, and purchases the entire field, thereby gaining the treasure. Jesus says, "That's what the Kingdom of Heaven is really like."

We take that story, and begin to make immediate allegorical application. Humans are represented by the guy who finds the treasure, while the treasure itself represents the Kingdom of God. Our application is that we need to sacrifice whatever it takes to acquire the Kingdom of God. It's a treasure in a field, waiting for us to possess it. Pushed to its logical conclusion, we buy the Kingdom of God.

But when you read the story in context, it may mean something entirely different.

If you look at all of the parables in that section of Matthew, you'll see consistent characters being highlighted. Here's what I mean.

Stay with me. This ends well.

THE SOWER (13:1-9) – In this story, there is a farmer who scatters seed. The seed lands on four different soils. Jesus later explains it: The Farmer (or the landowner) is God. The seed is the Gospel. The soils represent people.

THE WEEDS (13:24-29) – The very next parable in Matthew is about weeds. Once again, there is a farmer who plants good seeds. There's an Enemy who sabotages the whole thing by planting weeds with the good seed. Just like the first parable, the farmer (the man) represents God, the seeds represent the Gospel, and the people are represented by either growing, or not growing.

THE MUSTARD SEED (13:31-32) – Again, there is a man who plants (God), and there are seeds that grow (people's response to the Gospel).

Are you seeing a pattern here? The man (or the farmer, or the landowner) always represents God. And the people in all of these parables are seen as lying dormant, then having some life infused into them. They either respond to that life, or not.

THE TREASURE IN THE FIELD (13:44) – But when we get to this story, for some weird reason, we flip all of the characters around, and who they represent. We do something the original readers would never have done. We make "the man" represent us (instead of God), and "the treasure" represent the Kingdom (instead of dormant people who are offered an infusion of life).

But in keeping with the pattern already established by Matthew, the story reads differently than our normal interpretation.

The Kingdom of heaven is like a man. Stop there. **The man in all of these parables always represents God**. So the Kingdom of heaven is a realm in which God finds a treasure in a field. And we have nothing to do with finding the treasure. In Matthew's already-established pattern, it's way better than that.

We are the treasure.

We are passive objects lying dormant, waiting for life to be given to us.

And then, this man went and "sold everything he had to buy the field". Could the cross possibly be described as anything other than God giving up everything He has to buy back his beloved?

And here's the kicker. God did this all "with great joy". Why? Because the possibility of bringing this exact treasure into His presence makes God overjoyed.

The possibility of you in God's presence makes God overjoyed. And while this sounds too good to be true, it's true nonetheless.

Welcome to grace.

Welcome to life as a child of God.

DIVORCING ART

With all this true talk of identity, I want to share a portion of my reality. The following is a journal entry from April 2009. You'll see how this battle works itself out in the lives of artists - the battle between Identity and Art.

I'm not proud of this, but it's true.

Two nights ago, I didn't sleep well. I was experiencing the anxiety of a new video for Easter, set to be released the next day. We would promote it, offer a great sale price, and see if any church out there wants to buy it.

No big deal. It's what businesses do every day.

Dream up a product.

Design a product.

Test a product.

Market a product.

Sell a product.

If you're an artist, everything changes because the art is inextricably linked to the artist herself.

For years, I've heard that artists need to learn to divorce their identities from the art they create. In other words, worship leaders shouldn't discover who they are in the songs they sing. Filmmakers shouldn't find themselves in the films they create. Writers and bloggers shouldn't view themselves in terms of the words they write.

I get that. I understand it. I even agree with it.

I just can't seem to do it.

When I was a worship pastor, I lived and died with every Sunday's worship set, and all the creative arts elements that went along with that.

As a filmmaker, I live and die with every new release.

As a writer, I care if people respond. It matters what you say about what I say.

Am I finding my identity in these things? I want to be able to say no. I want to tell you that the only identity I care about is the core identity of being a child of God. I really wish I could say that, and mean it.

But I can't.

This identity thing will be one of the primary wars my heart will fight until the day I die. But if you're an artist, we'll be in the trenches of this exact battle, together.

For better or for worse, I am a child of God who cares deeply about impacting the world through the creative arts. I will not always succeed in divorcing myself from the art I create. For much of the time, it is me and I am it. And so I will spend countless nights, lying awake with the anxiety of a new piece of art being made public.

Because at the core, I have taken a piece of my own deepest soul, and made it available for you to critique.

And that's scary as hell.

PEOPLE PLEASER

Many artists are people-pleasers. I would tell you that I'm a people-pleaser, but I'm a little worried about what you might think of me.

Recently, I sat for an hour with four new friends. I had never met them, but we would be singing together on the church stage the following Sunday. They were all great people, as diverse as night and day. So I led them through four songs. We had fun, and we got the job done with excellence.

But when it was done, my heart felt lifeless and tired. There was an odd and vivid weariness in my imagination.

Come to think of it, whenever I'm asked to lead a group of people I don't know, I always feel lifeless, weary, and tired afterward.

So on my drive home, I started talking with God about the relationship between leading and my very tired heart. And to be honest, I had a Moses-at-the-burning-bush experience. I even had to pull over to the side of the road. Moses took off his sandals. I pulled over on a busy street. Same deal.

As I sat there, I had an acute awareness of what God might be saying to me. If only I would listen. His faint voice sounded something like this:

**Spending that much energy trying to get people
to like you will eventually kill you.**

And there it was.

Truth.

Ever since I was a little boy, I've sought the approval of others. Getting their approval has always been the prime struggle in my life. And for people like me – people who are always secretly hoping they'll gain the approval of others – we either renounce it and deal with it, or we do what I've becoming prone to doing.

We pose.

Our lives become a complex series of subconscious decisions, all designed to keep people near us, thereby gaining their approval. And when we do it enough, we don't even know we're doing it. It's simply the way we live.

This self-imposed addiction to gaining the approval of others becomes the new normal. It's life after the Fall, and I never tasted the prior beauty of the Garden.

So on the side of the road, I ask myself something. I ask if this can possibly be the life Jesus came to give? Not a chance. It's not life. It's death.

And just typing these words, and knowing you'll be reading them, is my confession. And it's amazing how much life I feel simply typing these words, in this manner, at this time.

Life-giving.

I need to listen to that feeling.

And then, God speaks through His Word to my heart.

> *"Am I now trying to win the approval of men, or of God?*
> *Or am I trying to please men? If I were still trying to*
> *please men, I would not be a servant of Christ."*

(Gal. 1:10 NIV)

HIGH AND LOW

A senior pastor I worked with was working his way through seminary, and needed to interview me as part of a project. This interview would constitute a large portion of a counseling class he was taking, so it was a big deal to him. And to me.

But I didn't know it yet.

He interviewed me with a ton of artist-type questions, primarily aimed at my personality characteristics, and at how I tend to react in certain situations. I loved it, because it gave me a chance to share some deep parts of my heart with him, but not in a submissive/leader relationship.

It was just two guys talking.

My pastor grouped his findings about me together, and then formulated that group into a presentable paper. Many core parts of my personality were on display to my boss, and now to his seminary professor.

A month after the paper was completed, my senior pastor asked me to step into his office. He wanted to share some things that his seminary professor noticed about his project.

He wanted to share her findings about me.

He shared plenty of good and positive things the professor said about me. But I don't remember any of those. The only thing I remember the seminary professor saying about me is this...

"Gary lives in either heaven or hell. He should learn to live in Hades."

The professor wasn't being positive about that indictment, nor was she making a joke. She was dead serious about something she saw that needed correcting in order for me to become a more healthy, well-balanced person. Without any introduction to me, she was reading me as someone who's either extremely happy, or extremely depressed. In me, she observed no middle ground.

Years later, I was sitting with a counselor friend of mine over coffee. Whenever a Christian makes a statement like that one, please read: "I needed counseling, but chose to disguise it as a coffee meeting."

So I was sitting with a counselor friend of mine over coffee. His name is Ron, and he's an amazing man. We had a good relationship, so as part of our normal conversation, he looked at me and said, "Gary. You are an artist. Because of this, you will experience higher highs than I ever will. But you will also experience lower lows than I ever will." Then, he said something I'll never forget.

"Don't try to change that, because you can't."

And after I pursued that with him for the next thirty minutes, I began to understand that, in his counseling experience, artists tend to exhibit extremes.

What the seminary professor was trying to correct, Ron was trying to leverage.

As an artist, I will always react to difficult situations with more grief and sadness than most people. But the opposite is true, too. The smallest success or idea that allows me even the dimmest glimmer of hope will always cause me extreme joy. And I need to stop crucifying myself because of this. I need to stop trying to hide it.

I need to embrace it.

So do you.

The more people I come in contact with, the more I realize how rare it is to meet someone who gets genuinely excited about anything. It's almost like people are scared to exhibit any real desire, for fear they'll be shot down, or misunderstood.

For fear they'll be told to learn to live in Hades.

Make no mistake about it. The best art is borne in the joy of heaven, or the pain of hell. God-fearing artists will experience both, and God will beautifully interact with them in both places. But to create from Hades - to try to become artistically motivated from a place of perfect balance between heaven and hell - will cause artists to create safer art that is less impacting on the viewer, and frankly more boring.

I think it would feel like castration.

So while artists need to stop living and dying based on every whim of our emotions, we also need to come to grips with the fact that, for many of our tribe, we will always exhibit high highs, and low lows. And when we place our ordinary lives on the daily altar as living sacrifices, we need to make sure and place this tendency on the altar as well, for God to mold and transform as He sees fit.

We may fight this reality for the rest of our days.

But we should also embrace its beauty.

Pursuit

The thing in my life I am most guilty of is failing to pursue Christ every day. Frankly, its hard to pursue anything these days. If anything, we are the object of a pursuit.

INTRODUCTION TO PURSUIT

Written by Jeff Parker

Facebook, Twitter, sports, blogs, current events, politics, religion, work, and more are all trying to chase us and steal our attention. Daily, we are wooed by artificial relationships, insignificant information, and illusions of urgency.

There are no easy answers (that I know of) for shaking free from what the world demands of us. And for the record, many of the things that vie for our attention are good things, but how they take hold of our attention is where our challenge lies. There's little doubt that our attention has been stolen. Our pursuit of Christ has stalled.

And the results are in. Our art has suffered. Our God is less famous.

The thing in my life I am most guilty of is failing to pursue Christ every day. It's hard to pursue Christ in the midst of pursuing my own fame. As an artist, I am but one blog entry, one tweet, one video, one book from potentially being famous.

But if we are to be great artists, we must remember we are His art. If we are to become gifted storytellers, we must first be aware of our part in the Story.

It's tempting being in arm's reach of the world's adulation. It misdirects our focus. It misleads our intentions.

And the results are in. Our art has suffered. Our fame is fleeting.

Have I mentioned the thing in my life I am most guilty of is failing to pursue Christ every day? It's hard to pursue Christ when it's so easy to fake that pursuit to others. Since we have been trained well, we can often mimic the passion needed for our work without truly being passionate. Because we know the elements of a good story, we can insert them when appropriate while quietly leading disinterested lives.

There should be no difference between our lives and our art. It is all the same. We all have but one body of work.

Yet, somehow we have made a distinction between life and art. We write stories of God's love to audiences, but then we fail to act out its message. We write songs for Sunday worship, but then we fail to sing during the week.

And the results are in. Our art has suffered. Our message is hollow.

I will mention one last time that the thing in my life I am most guilty of is failing to pursue Christ every day. It's hard to pursue Christ when I have not allowed Him to pursue me. We must first be provoked. Compelled. Directed. Shaped. Molded.

If we are to love, we must be loved first. If we are to teach, we must have been taught first. If we are to pursue, it is because we have been pursued.

Circumventing these processes leads to a breakdown in what God intended. Thus, filling our art (and lives) with either half-heartedness and/or half-truths.

And the results are in. Our art has suffered. Our audience is misinformed.

DISCOVERING THE CREATIVE SOURCE

For those artists trying to make visible the invisible God, there's often a demand placed on your shoulders to be creative.

Easier said than done.

A SHORT STORY

A weary artisan traveler has been wandering in the desert of creativity for days. Her heart is dry, and her lungs are lined with sand. She desperately needs to discover some notion of some idea that is, in some way, creative. Her village elders are counting on her to create – to bring their ideas into an existence that stirs, and inspires, and communicates.

In the distance, she sees the beautiful image of a well. She drags her sand-caked feet toward the image, and reads the hand-carved sign on an old piece of wood, propped up against the well.

The sign reads, "Creativity".

She places her wind-burned hands against the circular cobblestone wall that surrounds the seemingly bottomless hole in the ground.

She cups her hands, she leans down, and she fills her palms with...

Nothing.

The air from the empty well whisks upward, through her hands, through her hair, and into the sky.

The Well of Creativity is empty.

She's desperate, so she continues her journey. She discovers four, then five more wells. All have a sign near them that promise "Creativity".

And all are empty.

After severe disappointment and extreme thirst, there appears one well in the distance. Any hope for finding the Creative Idea has been reduced to ashes, and she questions whether or not to even approach this well. Her

heart is weary, her lips are dry, and her village needs her to return with that sacred gift. And soon.

She moves toward the well, and sees a wooden sign, propped up against the stones. But the sign says something different at this well. Rather than "Creativity", this sign says...

"The Living God".

She leans into the well, barely. She cups her palms together, reaches down, and is immediately flooded with the cool waters of a Creative Idea. She's finally discovered what she's been searching for all along. And now, her fruitless searching has borne sweet fruit.

A Creative Concept that will benefit her entire village.

She arrives back in that village, and her elders question her about the creative idea she's returned with. Her explanation is simple.

She respectfully speaks: "I found The Well of Creativity to be empty – time and time again. While there were many people seeking to drink from it, there is nothing there. It may have even been a mirage."

But she continues...

"When after many days, however, I discovered The Well of the Living God, I was supplied with the Creative Idea I was searching for, and that our village needed."

Two of the village Elders simply stared, but one smiled.

He had been on the same journey years before.

MEANING

You are the media creators, the storytellers, and the musicians. You write blogs, you lead people, and you challenge hearts. You are the artists.

You are Big Art.

You will create the most impacting art when your art is a byproduct of time spent with the Creative Source.

Jesus.

That's His name.

As artists, we may want to skip the Relationship and move directly to the Great Idea. But when we run to a well that promises creativity, many are empty. When we seek creativity, sometimes there is none. But when we run to deep and intimate interactions with the Living God, creativity is given to us, never as an end.

But as a gift of the relationship.

PREPOSITIONS - ONE

When my father was still with us, my family decided to take him on an Alaskan cruise. It was something he'd dreamed of doing for most of his life, and we all felt like we should just make it happen. It was the summer of 2010.

We sailed.

My dad suffered from Parkinson's disease, along with the inevitable low-grade Dementia that accompanies all Parkinson's patients. He was beyond the point of caring for his own needs, and had all but lost any basic problem-solving abilities. He couldn't walk, and needed someone to lift him from his wheelchair, to his bed, to his bathroom, and back to his wheelchair.

With the help of our wives and children, my brother and I did everything for my father while we were on the cruise together. We gave him his regular cocktails of medication, three times every day. Either my brother or myself slept in his room to make sure he wasn't confused during the nights. We got him dressed and ready every morning, and then back to his bed every evening. We made every scheduling decision for him.

I'm not gonna lie to you. Taking care of my dad felt like I was taking care of a two-year old. Everything a two year-old does, my dad did, minus the tantrums. It was a very laborious task, to be sure. I struggled with doing the right thing to honor my father, while also having feelings of wanting to be cut loose from this never-ending anchor of constant service.

But three days into the cruise, something beautiful happened. The night before had been a difficult one for my father, so I didn't get much sleep. The ship had rocked back and forth all night long, and had left me feeling a little sick. We awoke that morning, and I put my dad into his wheelchair, and rolled him over to the edge of the sliding glass door, which led onto his balcony. I opened the curtains.

Together we were both blown away by what we experienced.

Snow capped mountains that lost their peaks in the blurred edges of grey-white clouds, all nestled on a lower-third of ocean water that could easily

have been glass. Whales blowing white water into the brisk marine air, as the sun appeared with glory through the clouds. Any adjectives would be gross understatements.

I ran up to the Lido Deck to get us both some coffee. I returned to our room, where we just sat - my father and I - sipping coffee and drinking in a generous portion of God's artistry. My father looked at me, smiled as much as he could, and said, "Ohhhhhh boy."

And there it was, as plain as day. There was tremendous honor in living for my father - in serving his every need so that he could join us on this grand excursion. But for a brief moment, I stopped living for him, and started living with him - right there, on the balcony of our ship. And at that point, honor turned into deep joy and beautiful fulfillment.

There's a world of difference between living **for** someone, and living **with** someone. And you might be surprised to know that, while both living for God and living with God are found in Scripture, one seems to carry the bulk of the weight for His desires toward the relationship He has with His sons and daughters.

PREPOSITIONS - TWO

Artists can easily become obsessed with doing things for God. We pledge our allegiance to Him, then vow to create art for Him. It becomes all about what we accomplish on His behalf. It feels more like we're soldiers in an army, than broken lovers in intimate relationship. Like we're creating artistic widgets on a production line in a factory, rather than sitting in a garden and simply letting the fruit of our lives hang from the tree of the art that's being produced through us.

While there are references to what we do for God in Scripture, the overwhelming admonition from Scripture is not what we create for Him.

It's what we create standing next to Him, knowing that He's with us.

> *"The Spirit of the LORD will come upon you in power, and you will prophesy with them; and you will be changed into a different person. Once these signs are fulfilled, do whatever your hand finds to do, for God is with you."*
>
> (1 Sam. 10:6-8 NIV)

> *"Whatever you have in mind, do it, for God is with you."*
>
> (1 Chron. 17:2 NIV)

> *"Be strong and courageous, and do the work. Do not be afraid or discouraged, for the LORD God, my God, is with you."*
>
> (1 Chron. 18:20 NIV)

In Jesus, the Word becomes flesh, and is called Immanuel, which means "God with us". We think that's theology or doctrine or part of a First Steps Class. It's all that. But it's also a statement of intimacy and identity.

THE PRODIGAL SON

The story of the Prodigal Son has been told and retold throughout the ages. Stupid boy runs away, lives in sin, and is welcomed home by his dad.

Older brother gets ticked because he wants his own young goat. We can all relate to wanting our own young goat.

The dad says something odd to his oldest son, never really answering the son's question. Then it ends. Just like that. Luke doesn't even try to make sense at all.

"The older brother became angry and refused to go in. So his father went out and pleaded with him. But he answered his father: "Look! All these years I've been slaving for you and never disobeyed your orders. Yet you never gave me even a young goat so I could celebrate with my friends. But when this son of yours who has squandered your property with prostitutes comes home, you kill the fattened calf for him!"

"My son," the father said, "you are always with me, and everything I have is yours. But we had to celebrate and be glad, because this brother of yours was dead and is alive again; he was lost and is found."

(Luke 15: 28-31 NIV)

Thanks Dad. And thanks Luke for that terrible ending. He may have benefited from the Developing an Effective Story Arch breakout session at the Writer's Conference.

But look again.

THE OLDEST SON'S WORDS

The oldest son says, "All these years I've been slaving for you..." I think that must be how he sees his life. He's a slave, working for his father. His relationship to his father is one of master/slave.

THE FATHER'S ANSWER

But the father's words are like a beautiful piece of art, demanding the viewer press deeper into what's already there. He says, "My son. You are always with me."

THE PRIMARY LESSON

Among all the lessons found in this parable, I think it's primarily an illustration of identity and behavior.

On the one hand, Jesus uses this parable to ask a question, illustrated by the behavior of the younger son: "What's my identity if I rebel and leave the father?" The answer is simple. You're still a son.

And the prostitutes rejoiced.

On the other hand, Jesus uses the story to ask a question, illustrated by the behavior of the older son: "How does a good son relate to his Father?" The answer is again simple. A true son is less concerned with what he does **for** the Father, and more concerned with simply being **with** Him.

And the Pharisees and the religious leaders started looking for stones.

FOR OR WITH?

Those little grammatical connectors can describe our days, and define our lives. They can frame our destinations in Alaska, on the Lido Deck, sipping coffee.

For.

With.

Those exact prepositions are right there in the story. And those exact prepositions will define our lives in Christ.

We don't create art for God. He doesn't need it. But He dreams of creating art with you, for the world.

It's how sons and daughters of the King discover Him as a Father.

THE PRISON OF FREEDOM

When I stepped out of pastoral ministry, I stepped out of an occupation I had begun to hate. The hours away from my family, the constant stream of impossible responsibilities, and the unwillingness of so many people to own their stuff became too much for me to bear. Those things became even more convoluted because I was unwilling to say no to people.

I think I resented myself more than anything.

During my first year outside of pastoral ministry, I experienced freedom. I experienced the ability to wake up every morning, and literally create the day ahead of me. During this time, I began to unknowingly define freedom as doing whatever I wanted to do, whenever and however I wanted to do it.

I think that's what North American Christians believe freedom is - the ability to do whatever we want, whenever we want. And I lived there.

During my pastoral detox, I learned to listen intently to the voice of my own heart, because I knew that the desires giving voice there were God-given. While it sounds cliche, it's true nonetheless: It was a broken and beautiful time for me.

But during this time, I continually and unknowingly lived in the middle of one primary mistake. The mistake had to do with my life of freedom. As I've already noted, I defined freedom as the ability to do whatever I wanted to do, whenever and however I wanted to do it. But I began to learn a different truth.

What felt like freedom, wasn't.

Yes - true freedom was about creating my days. But when I began using joy and happiness and artistic musings and fulfillment as the determining factors of its achievement, then I got screwed up. Did I have a day filled with freedom? Yes, as long as I was happy and glad at the end of it. But that wasn't freedom.

It wasn't freedom because there wasn't a cross.

Now that I've put some distance between that time and the present, I've taken on the task of figuring out what real freedom looks like, both in the excitement of creating new things, and in the mundane tasks of maintaining a business.

Mundane.

Difficult.

Scary.

Lonely.

I think true freedom has nothing to do with choosing tasks that make us happy. I think true freedom has everything to do with choosing tasks that allow us to live into a vast and enormous Narrative. We craft our days and our nights to partner with God in our telling of His Story.

Real freedom is the ability to tell God's story with your unique voice.

And here's the important truth about what I'm trying my best to communicate. Telling God's story with your unique voice may be wonderful and joyful and fulfilling. But much of the time, telling God's Story may be painful, and full of hurt and suffering.

If I'm honest, creating my days and my nights can feel like I'm swimming in wet manure. I'm not suggesting that the Story feels that way. I'm saying that much of the time, the tasks required to tell it certainly do.

In all of this, I learned that telling God's story with my unique voice requires that I consistently place myself into, what feels like a prison.

Real freedom involves a prison, because real resurrection involves a cross.

THE PURSUIT OF FREEDOM

That last bit was difficult for me to write.

Prison.

Cross.

Suffering.

I've read it over and over again. I've trashed it, rebuilt it, then trashed it again. I recognize that I may not have made any sense, and that you may not understand what I'm trying to say with regard to living in true freedom and liberty. But for me, this whole freedom thing has provided a monumental shift in the way I live.

So let me take another stab at discussing true freedom.

During the years after I stepped away from pastoral ministry, I had become someone who was pursuing freedom. Please hear that.

I pursued freedom.

Freedom was the end. It was the goal. So at the end of those creative days of making some sort of art, I was pursuing freedom. The last thing I wanted to feel when my head hit the pillow was freedom.

What I never understood was that freedom doesn't need to be pursued unless there's the presence of oppression. My friend Dave told me that, and it sounds too wise to be wrong. But in my life, I wasn't under any oppression. I didn't live in Egypt, under the rule of Pharaoh. I lived in North America.

Paul highlights the heart of freedom in his letter to the Galatian church. Into a developing belief system that was beginning to take advantage of Christian freedom, Paul writes the following...

"You, my brothers and sisters, were called to be free. But do not use your freedom to indulge the flesh; rather, serve one another humbly in love."

(Galatians 5:13 NIV)

He's just finished talking about whether or not grown men should be required to go back and get circumcised, as if that circumcision was a ticket into the Christian faith for them.

If that were the case, I don't think I'd become a Christian. Talk about a deterrent. All you have to do is trust Christ with your life. Oh - and you need to have your foreskin removed.

I'm very sorry about that reference.

Freedom is something that Christians have been called to. Paul speaks of it as something that's already been given - as something already possessed by Christ-followers. His primary concern isn't attaining freedom.

His primary concern is what we do with it.

We can either use our freedom as an opportunity to indulge the flesh - to do whatever we want to, whenever and however we want to. Or we can use our freedom as an opportunity to serve - to live large into the lives of others.

There is no better way to exert our artistic freedom than to serve others with it.

I think it's very easy for Christian artists to live in North America, and to practice the pursuit of freedom. I think we're responding to an oppression we feel from clients or senior pastors or people in authority who don't understand us.

But I think we really need to learn to stop practicing its pursuit, and beginning practicing its presence.

Authority

Lately, I've noticed something about my career. I've noticed that I'm often most concerned about me. I'm often preoccupied with what I want to do – with what I think is best...

INTRODUCTION TO AUTHORITY

Written by Scott McClellan

I'm smart and conscientious and mildly creative, and I want to make a contribution. But I'm relatively young, which means that even when my heart is in the right place, my eyes fail me because they haven't really learned to see.

Several years ago, a coworker and I received the opportunity to create a promotional T-shirt for our company. My guess is that this was a calculated risk on the part of my boss - Rob Thomas (who has also contributed a chapter introduction to this book). There was a good chance we might do a bad job, but it was an opportunity to see what kind of work we would produce when given a little freedom.

Long story short, we did a bad job, and I see that now. I really do. I think what happened is that my partner and I created exactly what we wanted—a quirky, niche design for a particular sense of humor at a particular time. The main problem was that we weren't the intended audience for this shirt, but we couldn't see that at the time. Neither could we see the lack of intentionality, branding consistency, or staying power in our work.

Our eyes failed us.

We were arrogant enough to bristle when our boss expressed hesitation. We pushed back and he let us proceed. This was a long time ago, but I recall some tension during and after that conversation because we knew we were right in spite of the perspective of our leader. Imagine our surprise when the shirt received a lukewarm reception from the people for whom it was meant to be a gift.

We didn't see that coming, but we should have. We were even immature enough to insist all those people were wrong too. We just couldn't see.

Our eyes failed us.

Up until recently, we still had some of those shirts in a storage closet at the office. How embarrassing. Although in a way, I'm thankful. Every time I saw one of those shirts (or when someone asked, "What the heck are these?!?"), I had the opportunity to think about what went wrong, what my boss wished I'd been able to see, and what I ought to do differently next time. I also shudder to think about how poorly I might've reacted if my boss had put a stop to our ill-conceived plan. I'm actually glad he let us try and fail.

So what is it that causes conflict between artists and the leaders over them? The easy answer is creativity. But in my experience, this isn't true. My boss is also an artist, and he's far more creative than I'll ever be. So what is it? What so consistently disrupts these relationships? What is the source of clashing opinions and priorities and visions? My guess is that we won't know for sure until our eyes stop failing us.

Until we develop eyes to see.

COVERING

I hate the word authority. Honestly, I do.

But I like the idea of someone providing a covering for me. I need a covering or two in my life. I suppose we all do.

In the Scriptures, anyone who has authority over someone else has the charge of providing a covering for them.

All authority exists - at some level - to cover people.

That's the way God designed authorities in our lives. They cover us from injustice, they protect us from evil people, and they lead us to the wellspring of life. They confront us when we're on a path that's destroying us. They help us become bigger people. They lead us. You know you're under the right covering when you feel safe, a little uncomfortable, and growing.

And the only way we know how important these authoritative coverings are in our lives are when they're removed.

After my parents both passed in the last half of 2010, I was trying to wrap my brain around what my heart was feeling. I missed having them around, but my heart was feeling something far greater than that. There's something extremely sad about picking up the phone to call your mom, then realizing that there's no one at the end of that line anymore. But that sadness was a symptom of something more, something deeper.

I discovered that the overwhelming sensation happening in my heart was simple. For the first time in my forty-six years...

I was uncovered.

You know that blanket you used to pull over your head when you were a kid? The blanket that protected you from the evils that only came out at night? With the death of both of my parents, I felt like someone pulled that blanket off. And they did it without my foreknowledge or permission.

It just happened so quickly.

My parents were no longer on this earth with me. And it took their passing to help me realize just how much they provided a covering for me.

A covering that protected.

A covering that provided me with warmth in the cold.

A covering that allowed me to try new things, without fear of failure.

A covering that helped me experience the Judeo-Christian God of the Bible as both a father, and a mother.

You have undoubtedly served a client, a leader, or a pastor who has provided this kind of a covering for you. But you've also served someone who, rather than covering you, abused you and left you unprotected. They were selfish and blinded. They needed you to get what they wanted, and they quoted the right Scripture to get it.

I think that's why Jesus was so harsh with the Pharisees and the Religious Leaders. They were placed in a position of authority, but they didn't cover. They invited people into their kingdoms, but never offered them an entry key. The people collapsed under the weight of their leaders' expectations, and the leaders continued expecting even more. Their people were not covered.

They were exposed.

I'm left a little out of breath at this point. Somewhere in between the Gospels and my own experience of abusive authority figures, I find myself asking...

What kind of covering am I providing my wife, my children, and my workmates?

It's easy to point to abusive authority figures in our own lives, and harbor resentment or bitterness or anger or hostility. That comes naturally for most artists, and it takes an intentional act of forgiveness to get past that stuff.

But we also need to become courageous enough to turn the finger-pointing back around in our own lives.

Do the people we have authority over feel covered, protected, and loved by us? Or are we achieving our own dreams, all the while using them to get there?

I wish I could have told my parents how appreciative I am of the covering they consistently provided. But I honestly didn't realize any of this until it was too late.

And I have a feeling that they're fine with that.

DEFUSING THE BOMB

If you're an artist, and if you regularly create art for public display, then there's a bomb waiting to go off. I'm very sorry about the violent analogy.

The bomb seems to detonate when the creator of the art presents the final product to the organizational leader.

Boom.

Artists have been told to come under the authority of the Project Manager, or the Senior Leader. Sometimes, there's a beautiful covering in place. But sometimes, the process requires the artist go back and change or recreate the entire artistic piece. And the artist is to do this with a smile, in the name of submission. But if you ask any artist, they'll tell you that even though biblical submission is the goal, resentment can creep in and overtake an artist's heart.

Especially when the pattern repeats itself over and over again.

I'm more interested in defusing this bomb, than in teaching artists to be quiet. So I'm suggesting two questions for the artist to ask the Leader at the beginning of every project.

WHAT DO YOU SEE?

Simply ask that question to the guy in charge. Do you see images or themes? Are you inspired from another church, another video, another branding concept? Can you give me two or three examples of what you like?

WHERE DO YOU WANT THIS TO END?

In the case of video (and sometimes music), the artist needs to know how to end the piece. Is the piece resolved, or left hanging? Does it end with a question, a bold statement, a series graphic? Should people feel inspired, doubting, wondering, flat, or up?

The Senior Leader's responsibility is to be prepared to answer these two questions with as much detail as possible. The artist's responsibility is to ask these questions, and take notes as answers and ideas are given (writing things down also helps defuse any potential explosion).

When information like this is exchanged before the project begins, it heightens trust and builds the relationship between leader and artist.

And in the end, isn't it far better to defuse this bomb, rather than letting it explode?

SUBMITTING AND DISAGREEING

I enjoy submitting to anyone. It brings me great fulfillment to voluntarily place myself under the authority of someone else. I love it when someone tells me to create something, within certain guidelines, with a specific look and feel. I really do find satisfaction in submission.

As long as I agree.

The problem comes when I disagree, and have to submit anyway. I hate that.

Like the no-jeans dress code at church.

Like the no alcohol in public policies imposed by Christians in certain sections of my country.

Like the removal of the best part of a short-film because it's too long for that market.

Submission doesn't really come into play unless we're being told to do something that we wholeheartedly disagree with. It's easy to submit when we agree - when we're heading in that direction already. But our hearts perform emotional cartwheels when we're told to move in a direction that we think is silly.

Or stupid.

Or ignorant.

Or naive.

Or irrelevant.

And I think it's even worse for people who were born with an artistic bent. Artists pour their hearts into the art they create, so when they're told to go in a different direction, what they hear is: "Your heart is wrong." Team Leaders normally don't intend to communicate that message, but it's what artists hear.

And if that scenario plays itself out over and over during their days, artists will eventually stop creating from their hearts, and start creating safer stuff that their authority figures will approve of.

Which makes me wonder. If you're a Team Leader exerting authority over artists, and if those artists consistently miss your mark, you probably either need to change your artistic preferences, or fire the artist. Both could be the most gracious gift you might give them. Because I promise you - they're already more frustrated than you are.

For artists, I think you can disagree with authority, and still submit to them.

SUPPORT PUBLICLY, DISAGREE PRIVATELY

Support your leader publicly. Support the vision of the organization publicly. And if you disagree with anything, simply communicate your disagreement in a private conversation, behind closed doors.

TRY THE IDEA, THEN REPORT BACK

If an authority figure wants you to try a new idea, and if you disagree with that idea, communicate something like this. "I'm not sure I agree with that, but I'll give it a try, then get back to you. How long should we try this for?"

BE SUBMISSIVE, NOT SILENT

This was the biggest mistake I made as a pastor. I confused silence with submission. I thought they were the same thing.

They're not.

The pastors I worked under would tell you that they wish I would have been more honest with them about how I was feeling, about how strongly I disagreed with some areas of their delegation toward me.

And I would tell you that there's power in a verbal confrontation, and that confronting someone is not the opposite of making peace with them. I would also tell you that my silence turned into deep resentment, and that I'm still dealing with that today.

When artists are required to submit to someone's creative authority, and when they get that weird sick-in-the-gut-I'm-gonna-kill-him crazy feeling, there are two questions they need to ask, immediately and silently, to God.

WHAT'S GOING ON IN MY HEART?

Most artists have already learned to pay attention to their hearts, so this question won't be too difficult to answer. Is the creative vision being changed at the last minute, so you're feeling devalued? Is it just a pride thing? Were you genuinely excited about the creative vision of the project, and the changes you're being asked to make will lower its quality? Is this simply a personal preference issue? Is this a control thing on their part? On your part? Are you sick of the project, and just want it to be over?

IS THIS HILL WORTH DYING ON?

If you're going to battle, there's a good chance you'll die on the battlefield. So is this exact thing worth giving your life for?

HOW AUTHORITY WORKS

Here's the way authority works. If I'm doing a creative project for a client, a church, or a senior pastor, they are my direct line of authority. I answer to them. God is looking at me asking, "Gary. Are you submitting to them?" When it comes to my heart and biblical submission, that is **the only** question God is asking me.

I submit to God by submitting to them.

I can't say this strongly enough. That is my only concern. When I do what they say, whether I agree with it or not, something in the heart of God is pleased with me. He may or may NOT be pleased with my authority figure, the creative process, or the micro-management being forced down upon me. But He is pleased with me. I can push back, but in the end, I must submit.

For Christ's sake.

In those moments, we must trust God enough to know that He's also looking at them. He's asking them if they're providing the kind of authoritative covering that is both protective and loving. My authority figure doesn't answer to me.

He answers to God.

I answer to him. He answers to God.

And if he's leading artists poorly, then he'll answer for that. I don't know what that means exactly, and I don't think I'm talking about the Great White Throne of Judgment, or the Bema Seat (whatever that means). But I don't need to know what that means. It's not in my job description to figure it out.

Because my boss is not my responsibility.

He can make life miserable for me. He can frustrate me. He can undo weeks of creating with a single authoritative edict. But he is not my responsibility.

And once I've thought through this stuff - once I've honestly poured my heart out to God, telling him how pissed off I am, I've got three choices.

I can do whatever my boss says to.

I can push back, and come to some middle ground. Maybe I can keep the font choice, but lose the dove and the fish.

I can quit.

There's one thing I cannot do. Please hear exactly what I'm about to say, as if from a 46-year old guy who didn't understand this when he was in his 20's and 30s.

I cannot continue to remain employed, all the while disagreeing with everything my boss tells me to do, complaining about him incessantly, but never to his face.

If I do that over the long term, then I'm the one who will be answering to God.

Maybe even at the Bema Seat.

Whatever that means.

Blocks

There's a war going on in every person who has a
dream to do anything. I really believe that. I
love dreaming of creative things I can do or
accomplish. Some of my dreams have...

INTRODUCTION TO BLOCKS

Written by Rob W. Thomas

...become realities and I absolutely love the final product. I enjoy seeing something come to fruition.

I had a dream to create a DVD of sermon illustration videos back in 2001. I loved the beginning of the process and I loved the end of the process. The hard part - the place where I experienced the block - was in the long middle.

I started to realize just how hard it is to do anything that was worthwhile.

Completing a DVD of five short videos (including a web store and database) sounds pretty simple. But it was one of the hardest things I've ever done. It took major effort. It took my time, my discipline, and my creative thinking. I found myself exhausted quite often. Finally though, I accomplished what I set out to do and have built a company on it.

Unfortunately, not all of my dreams turn out this way. In fact, I don't even want to think about all the dreams or goals I've let go of, simply because I couldn't muster the strength to work through the blocks.

It's always the middle part of the journey that zaps my strength and beats me into submission. That's where the blocks appear. I struggle with fear, with laziness, and with lack of discipline. Those are my personal biggies.

Since 1996 I've dreamed of creating a children's series of sorts. Being a big fan of The Muppets, I always wanted to create a world of my own. But I never did anything about it. I talked about it occasionally. When asked in college what I wanted to be doing in five years, the answer was easy. I wanted to create some sort of kids show or series. Have I created this series? No, I haven't.

In the past three months, we've decided at our company to push forward with this idea and make it a reality. I am extremely hesitant to even mention this. Why? Because I know how hard it will be to accomplish it. It

will take large doses of the things I seem to often lack - the things I listed as my personal biggies. My shaky confidence wants you to check out our site in twelve months. By then we should have a children's series. But unless I learn how to work through my blocks and obstacles, it will not happen. Unless I get to the root of what is stopping me from moving forward, I'll stay where I am.

Unless I do what I don't want to do, I'll never get what I dream of getting.

The truth is, this process never seems to end. Every project I'm a part of requires me to work through the blocks. Every dream I want to see happen requires that I work through the blocks.

Blocks that seem to get larger with each new creative idea.

Blocks that never go away.

PROCRASTINATION

Most people I know are prone to procrastination. When it comes to our beloved artistic tribe, procrastination can rule us. It seems like our art is always something in the future, or when I get around to it, or whatever.

I decided to write a book. This book. Ten years ago. Until now, the book was nowhere to be found on any bookshelf - virtual or storefront or otherwise. But with the advancements in publishing techniques, it's become easier than ever to get a book printed, bound, and into your hands. It's also less expensive, requiring less out-of-pocket costs for me.

It seems like God took away my excuses - excuses which allowed me to put it off any longer.

Procrastination.

All talk - no action. When we procrastinate, we put something off, claiming that we'll get around to it someday. The problem with someday is that it's not a real day.

The great news is that I've found an antidote for procrastinators, like me.

The antidote for procrastination is accountability.

I know. When I think of accountability, I picture men praying early in the morning at the IHOP, or women crying over flavored coffee in a living room. I think those methods of accountability work for some people. I know people whose lives have been changed by this kind of accountability, and they are some of the finest people I know. But they've never worked for me.

For me, I need the concept of accountability to become beautiful and fulfilling. Not easy. Not simple. But attractive.

So for three days, I secluded myself to a small mountain cabin. I didn't know anyone with a mountain cabin, so I started praying about it. A friend of a friend of a friend offered to let me use his cabin, free of charge. One bedroom, small kitchen, and a working coffee maker.

And the very best thing I did to get past my procrastination was simple.

I put a date on the calendar.

That's all the accountability I needed. Once that happened, I just needed to drive up to the cabin, and engage wholeheartedly in what I'm supposed to do.

Write.

I'm telling you the truth - putting a date on the calendar is **the** primary accountability tool in my life. I hate to cancel on people, so it works every time. And more importantly, it helps bridge the gap between creating art and creating excuses.

Aren't you sick of creating more excuses than art?

The best way to create art that makes visible the invisible God is to begin. And the best way to begin is to put a date on the calendar.

FEAR AND PRIDE

If you are a Christian who has anything to do with presenting any art to the world, then I promise that God is conforming you into the likeness His Son. You already know that. And if you have anything to do with presenting any art to your world, then I also promise that God's conforming work is coming your way in the form of a Divine invitation.

It's a violent invitation, from a loving God.

The offer of the Divine invitation is not to Twitter fame, or to blog greatness. It's not an invitation to Conference Speaker prominence, or to Pastor celebrity. And it's most definitely not an invitation for artistic prestige or notoriety. The invitation is not extended toward you for your greatness at all.

God's invitation to all of us is to die. It's violent. It's painful. It's crucifixion. And for most of us with any artist leaning, God seems bent on helping us crucify two core inclinations.

FEAR

God is working in our hearts so that we become less and less fearful of what people will think of us.

2010 was the most difficult year of my personal and professional life. I started out the year by blowing out my back - to the point where I couldn't walk for a month. In January, I finally made the difficult decision to leave the church I once pastored. During the first quarter of the year, Floodgate Productions almost went belly-up financially. On May 31, my 81 year-old mother passed, after a surprising bout with a weird and untreatable intestinal disease. Three months later, my 87 year-old father joined her.

But in the center of all the pain and tears and cussing and yelling and questioning and doubting and anxiety, God has been crucifying something in me. He's been muting the voice of the demons - a voice that's always screamed, "What will people think of you?"

For me, the crucifixion occurs as He pounds nails into any need for me to worry about the answer.

That's the root of everything most artists are truly afraid of. We're afraid of what people will think about us. But God took 2010 and helped me believe that the shifting opinions of people pale in comparison to the vitality of my health, my calling, and my family. The pain makes me care less about opinions.

I think the fear of what people think will always be with me. But I think the voices don't have to be as loud as they once were.

PRIDE

If God is not crucifying fear in the hearts of artists, then He's probably busy crucifying our pride. That's the other side of the same coin. He's violently putting an end to any pride that links the amount of Twitter followers to the core of our identities. He's killing any pride that deeply resents those authority figures who want to help us create better art. He's stripping away the false life of any pride that would rather make known our amazing current media projects, above making known our amazing God.

If you tend to overestimate your own personal greatness, then I promise that God disagrees.

Christian artists can be the most prideful people on the planet. You already know someone like that. And into a heart that's prideful, God's word shouts with the boldness and clarity...

"...in humility consider others better than yourselves. Each of you should look not only to your own interests, but also to the interests of others."

(Philippians 2:3-4 NIV)

DEATH AND LIFE

When God invites Christian artists to become conformed to the image of His Son, that invitation will most likely involve surrendering one of two possible inclinations to Him. It's either fear, or it's pride. It all flows from there.

So for anyone who has anything to do with presenting any art to the world, the invitation to Christlikeness involves death. An all-loving God seems fine with pounding the nails and fashioning the crossbeam.

And oddly enough, when we accept and embrace this violent summons, we begin to experience what we were created for in the first place.

We experience life.

SATAN

We all have scripts we're writing. We're trying to write a better script for this season of our personal life, our family life, and our church life. We're attempting to figure out how these smaller scripts fit into the larger Grand Story that God is telling.

So we write.

Whether we know it or not, we're all authors and bloggers. Every day, we write scripts. It's what we've been called to. It's what we live to do. It's art. It's storytelling. It's beautiful.

But the opposite is true as well. We all have scripts that are writing us. These scripts can be overwhelmingly positive. But they're usually not.

Our scripts usually consist of accusatory internal and external voices speaking to our hearts. In a moment, these unseen voices seem to grab ahold of our distant past, throw in a few collaborating voices of current friends and family members, and spew out sentences we've come to know all too well.

They'll leave you.

You're not competent enough.

Your art isn't good.

No one will read it.

Don't let them see the real you.

You're too screwed up to impact others.

You can't help addicts, because you're one of them.

We're not even aware that we've come to live our lives believing in the unquestioned validity of these voices. The problem isn't that the voices are there. The problem is that we've become so accustomed to them, we aren't even aware that we're living under their abusive authority.

We've stopped recognizing them as false messages, and started recognizing them as normal.

These voices have become our scripts. And we live according to the script they've written for us.

Jesus warned His disciples that "the thief comes to steal, kill, and destroy" (John 10:10 NIV). The constant stream of these messages spoken to us is the primary way he steals, kills, and destroys the deep heart of artists.

In another crazy passage of Scripture, the Christmas story is told, but from behind the spiritual curtain.

> *"The dragon stood in front of the woman who was about to give birth, so that it might devour the child the moment he was born. She gave birth to a son - a male child who will rule all the nations with an iron scepter. And her child was snatched up to God and to His throne."*
>
> (Rev. 12:4-5 NIV)

Pull back the curtain, and Satan was there. He was present in Bethlehem, waiting to kill Jesus.

After that, there a few verses that weird me out. You'll have to figure those out on your own, because I have no idea what they mean. But in verse 17, it all starts making sense again.

> *"Then the dragon was enraged at the woman, and went off to wage war against the rest of her offspring - those who keep God's commands and hold fast their testimony about Jesus."*
>
> (Rev. 12:17 NIV)

I know. Insane description of Bethlehem. It's an insane description of our lives today, too. Because the most important line is that last one - the one that says that Satan is coming after Christ-followers with rage and with vengeance.

You hurt a Father most by harming His children.

We can all agree that there's resistance every time we try to create good art. But Scripture gives a name and a personality to that resistance. And in this passage, the name and the personality is also given motive.

81

One of the most difficult seasons of my life was to go back to my childhood, and to begin to identify specific voices that I unknowingly allowed to write my script. I had to revisit my childhood and teenage failures, figure out what lies I came to believe during that time, then begin praying against them.

I'm not writing this so you don't sleep tonight. And I'm begging you not to go looking for a demon under every rock. They're not there. But I think it's extremely important to identify what scripts are writing you. Maturing artists are figuring this stuff out in their lives.

Because as you make visible the invisible God in your art, God is busy creating His own redemptive masterpiece in you.

And accusatory voices need not apply.

PERFECTIONISM

Perfect is a myth.

Even after the cross and resurrection of Jesus, Paul wrote these words:

"We ourselves who have the first fruits of the Spirit, groan inwardly as we wait eagerly for our adoption to sonship - the redemption of our bodies."

(Romans 8:23 NIV)

We live in a space and a time when we've been given the first fruits of the Spirit of God. But even though the Spirit of God is alive and active and entirely resident in our lives, we still eagerly desire something that hasn't happened yet.

Our lives are excellent. But they're not perfect.

I think the art we create needs to reflect the same thing. Every artist at every ability level can be excellent. They cannot be perfect.

Excellence requires that we take all of the ability given to us, and intersect that with all of the resources at our disposal. And we create from that exact intersection - Ability and Resources.

Excellence then requires that the art created in that intersection be shown to other artists at similar intersections, in order to gain their honest feedback. These are trusted fellow travelers who speak into the art we create, without killing our inspiration. Choose wisely who you travel with.

Excellence finally requires that our art goes public. The artist defines who their unique public includes.

At no point in this creative process is your excellence compared with my excellence. The two look and feel and taste and touch and smell entirely different.

When I look back at some of the short-films I've created, or the writing I've done, I'm embarrassed. I think I create art today far better than I used to. Other artists have told me that, too.

But I don't create anything that's more excellent than I used to. Years ago, I created my art with the Ability and Resources at my disposal, with the honest feedback of other artists, and with the understanding that my art would be seen or read by others.

And that's exactly what I do today.

When artists begin comparing their art with other art that's more widely known and more globally distributed, it can cause us to get discouraged and derailed from creating anything at all.

But when we create art from our hearts, with the resources we've been given, then we more easily come to a point of actually finishing a project.

So go and be excellent today.

Perfect is a myth.

LUST

I remember that day like it was yesterday.

I was fifteen, and I was spending the night at my best friend's house. As the evening wore on, my friend pulled a Hustler magazine out from under his bed. The images were amazing.

Inviting.

Controllable.

Her eyes were looking directly at me. And hers. And hers. I couldn't seem to get past the sensation of something being so wrong, as my heart felt the sensation of becoming so alive. It raced with impossible possibilities. It was worship, to be honest.

The fact that I can retell a story that happened thirty years ago with such accuracy and vivid emotional detail should serve as a clue to you.

For me, lust is something that has never gone away.

It's like a roaring lion that I'm able to keep caged up for a season. But then, something happens that unlocks the cage, allowing the lion to come roaring toward me once again. Some of the time, I'm able to see him coming, and I put him back in his cage. And some of the time, he overtakes me.

I've come to identify the primary key that unlocks his cage. The key is called Control. I let this murderer out of his cage when I'm trying to regain control over some non-related aspect of my life.

I hope you heard that. Lust is all about control. It's a way for men to control the uncontrollable. It's also a way for some women to control some men.

The lion has brought me to my knees, causing me to cry out to God with great force and with uncontrollable tears. There's crazy irony here. In my striving to regain control, I end up more out of control.

And in my out-of-control state, a very real Enemy shouts one specific accusation over the entirety of my life. He speaks moral failure over everything that I am. Over everything that I will ever become.

Moral failure.

That single accusation can block any Christian artist from pursuing his craft. That single phrase can derail artists from creating art that makes visible the invisible God. When the roaring lion overtakes us, it makes it so much easier to just quit. The reason is simple.

It's because we think we're disqualified.

Somewhere in our thought processes, we believe that lust is the one sin that Jesus never saw coming. We think that, when God created us as artists and gave us the ability to create unique and beautiful art, He wasn't entirely aware of the lust issue that could overtake us.

Should we get on our knees and cry out to God? Absolutely. Should we get involved in Christian recovery programs? Yes. Should we rise up and fight this lion with every weapon in His armory? Certainly. Put on your kilt and blue face paint.

But should we allow any ongoing battle with sin to disqualify us from creating art?

Read it again. Slowly read that exact question again. Your answer to those words will either propel you into more beautiful and compelling creativity, or it will stop you dead in your tracks.

"So in Christ Jesus, you are all children of God through faith, for all of you who were baptized into Christ have clothed yourselves with Christ."

(Galatians 3:26-27 NIV)

You're not clothed with lust. You're clothed with the resurrected Son of God.

There is victory here. I promise there is. I experience victory every day. But the victory over lust won't come like a war that finally ends. Our victories over lust happen in this hour, in this moment, without any glance toward the same battle that will rage again tomorrow.

And the simple fact that this section of my life made it into a book that you would be reading - that I didn't pull it for fear or for embarrassment.

That's my victory.

OBSCURITY

I was talking with my friend - Dave - about creating art. We were talking about art in the largest sense. We were talking about Big Art.

More specifically, we were discussing the creative process - those voluntary steps we all take to get a piece of art from idea, to development, to execution, to distribution. We were throwing out names of artists and bloggers and best-sellers and filmmakers and musicians who had gone from obscurity to popularity. Dave noted one common characteristic of everyone we mentioned. He noted that they all created in obscurity for years.

Obscurity.

Years where no one had any idea who they were.

Years where their blog readership was 23 people - and where 4 of those people shared their last name.

Years where 500 people experienced their creations on a Sunday morning, never to be mentioned again.

Years where they attended conferences, but were never asked to speak at those conferences.

Years where they spent thousands of creative hours in a room where nobody saw, and nobody knew.

The Christian artists in our creative communities who I respect the most are not creating anything with the primary goal of getting famous. The artists who I respect the most would create their art if their name was never attached to it. And for years and years, it wasn't.

They just continued to do the work.

If there's anything I believe with passion - if there's anything I'll shout loudly from the rooftops while inadvertently spitting on people below - it's this.

Don't ever let personal obscurity stop you from creating art.

Please don't worry about becoming famous, or about making a name for yourself, or about maneuvering the spotlight to shine a little brighter on your face. It's one thing to get your art as broadly distributed as possible (a good thing), and that'll take a great strategy. But it's another thing to make personal popularity the end game.

Just continue to do the work.

Just continue to do the creative work.

Just continue to do the creative work for which you've been Divinely ignited.

And make the choice today and every day to humbly shine the spotlight onto the face of the One who died, and didn't stay that way.

Mirror

Her words were something like: "If you don't get over this thing with your dad, your marriage is gonna die." Nice words over coffee and a bagel right? The truth is these words...

INTRODUCTION TO MIRROR

Written by Candice V. Wilkins

....were the most beautiful words ever spoken to a human being. Because in that moment I came to my spiritual crossroads. Did my friend Jamie speak untruth? No. But was I ready to accept the challenge? I knew that God was asking me a life-changing question. "Candice, are you ready?"

He waited for my answer.

Before that moment I was on a bitter path. I was sad, angry, confused and I strived for control in practically every area of my life. I was also unappreciative of the amazing man that God had given to me as my husband. The path Jamie was offering me was one of immense pain, anguish even. She was asking me to honestly look at my crap.

When I was 18, my dad left our family. He chose another woman over my amazing mom, my two beautiful sisters, and myself. So for seven years I'd avoided this reality. I thought it would be too overwhelmingly sad to experience the anguish. But the Holy Spirit encouraged me. He spoke healing in my heart, that after the pain there would be peace, hope, freedom, redemption, and joy. Ultimately, what awaited me was a marriage based on who I was meant to be, not a relationship based on what my pain had made me.

I could barely see through my tears as I drove home from coffee with Jamie. There was a writhing pain in my heart that hurt more than any other pain I'd ever experienced - the kind of devastation a child feels when a parent leaves a scar like no other. My spirit was crushed, I had no self-esteem. Would I allow that scar to propel me forward in a life of sadness, denial and bitterness? Jamie didn't want that to be the case, so she held up the mirror and asked me the question.

Do you like what you see?

What followed were weeks of prayer and healing, not just for me, but for my husband Dave. Because you see, much to my astonishment, he

followed suit. Jamie, her husband Jon, and her friend Mariette came alongside both Dave and I to guide us through prayer, confession, and the release of our demons. What I had not been fully aware of until these powerful moments, was that my judgment of others - including judgment of my estranged father - was what had allowed me to stay in the bondage of unforgiveness and hate. When God and my friends showed me (and when I accepted) that I was just as guilty as the dad who had left, then I was released. In every spiritual and physical and emotional sense, releasing the others required releasing myself first.

If you're courageous enough to look in the mirror that God has put in front of you, and allow yourself to truly experience your pain, I believe you're going to free up a tremendous amount of room in your heart, mind, and soul to create art based on beauty that you accurately see, instead of what you see through your filter of pain.

The beauty I now see is the peaceful redemptive relationship I have with my husband, and the beauty of my three thoughtful, kind, and spiritually-minded children. I'm not filtering their lives through my pain or my experience. I'm living life presently with them. I'm now able to participate in what I feel is my life's calling as a creative, as a wife, as a mom, as a social worker, as a Floodgate Foundation board member, as an advocate for victims of human trafficking.

I believe there is a Divine invitation for each of us to look into our mirrors. I believe there is a Divine offer to take Jamie up on her offer. And to courageously answer God's question.

Yes, I am.

MISSING THE MARK

Confession is good for the soul, but terrible for the reputation. Especially for artists.

We artists tend to spend a good amount of effort critiquing those in authority over us. It's really the easiest thing to do, and sometimes it's justified. But every now and again, it seems like we need to wave the magic wand of criticism over ourselves.

I think it's probably the most courageous thing artists can do.

I'll move through some specific areas where artists can easily miss the mark. As I do, it's important to note that I've never met an artist who displays every tendency.

But some of us display some of them, some of the time. And it's important for all artists to have the courage to look in the mirror, and to not respond with any stink of a defensive victim mentality.

Here's what I've noticed in artists, most of them finding their source in my own heart - a heart that misses the mark with regularity.

I CAN COMMIT TO EVERYTHING, THEN FORGET

Ask me to grab a document, or to forward you an email, and I'll tell you "Sure. Right after lunch." And I never think about it again. Until the person in charge reminds me.

I DON'T WRITE ANYTHING DOWN

I honestly think I'll remember it. The best friend an artist can have is a boss or a project manager who gently whispers, "Did you want to write that down?" Better, I force myself to write everything down. It doesn't come naturally, but I've learned to do it.

I CAN LIVE ONE DECISION AWAY FROM DISASTER

Most people live five bad choices away from personal ruin. Many artists walk as closely to that line as they can because of the risk, and the rush.

I CAN STRUGGLE TO SEE THE BIG PICTURE

I think my stories are the biggest, and the most important stories being told. The lead visionary of the organization sees the clearest portrait of the organization's story. I do not. The key leader gets ticked when the organization isn't reaching its full potential. I get ticked when my software takes too long to render.

I CAN GOSSIP

Not all the time, but sometimes. Much of the time, I'm gossiping about the lead visionary in the previous paragraph.

I CAN DEFLECT BLAME

My first reaction is usually to find someone else to blame the problem on.

TWO STEPS TOWARD HITTING THE MARK

There's a pattern here. It always boils down to two things. If Christian artists could simply learn these two things, we'd be a lot better off, and we'd make more of an impact on those exposed to the art we create.

First we need to learn to follow through. Do what we say. Say what we do. Never walk into a staff meeting without a yellow pad and a pen. Immediately following every meeting, we need to transfer our to-do notes onto something we'll look at every day — our main computer, our wall, our secretary's forehead. Paint an office wall with chalkboard paint, and create a special drawing every week, made up of to-do's.

Second we need to take personal responsibility more seriously. Leaders already know we're not telling them the entire story. Our sins will find us out. We need to have the courage to simply say, "I'm sorry. I forgot. I'll take care of it immediately, then give you an update later today."

Our world would be flat without artists. But our world would never move in any positive direction without leaders. Above any other group, I think artists must become willing to look hard in the mirror.

And create beauty out of the brokenness we see staring back.

OBSESSED WITH RESULTS

We are obsessed with results.

The right result. The best result. The most profitable result.

Results become the bottom line, and as such become so important to us that we literally organize our entire days around getting them.

Growing our reach.

Growing our church.

Growing the viewership of our art.

I work for results every day. Without results, my business tanks. Results aren't bad or evil. We just need to be careful to remember one thing about results.

Results are never ours to own.

> *When one of the Pharisees invited Jesus to have dinner with him, he went to the Pharisee's house and reclined at the table. A woman in that town who lived a sinful life learned that Jesus was eating at the Pharisee's house, so she came there with an alabaster jar of perfume. As she stood behind him at his feet weeping, she began to wet his feet with her tears. Then she wiped them with her hair, kissed them and poured perfume on them.*
>
> *When the Pharisee who had invited him saw this, he said to himself, "If this man were a prophet, he would know who is touching him and what kind of woman she is—that she is a sinner."*
>
> *Jesus answered him, "Simon, I have something to tell you."*
>
> *"Tell me, teacher," he said.*
>
> *"Two people owed money to a certain moneylender. One owed him five hundred denarii, and the other fifty. Neither of them had the money to pay him back, so he forgave the debts of both. Now which of them will love him more?"*

Simon said, "I suppose the one who had the bigger debt forgiven."

"You have judged correctly," Jesus said.

Then he turned toward the woman and said to Simon, "Do you see this woman? I came into your house. You did not give me any water for my feet, but she wet my feet with her tears and wiped them with her hair. You did not give me a kiss, but this woman, from the time I entered, has not stopped kissing my feet. You did not put oil on my head, but she has poured perfume on my feet.

Therefore, I tell you, her many sins have been forgiven—as her great love has shown. But whoever has been forgiven little loves little."

(Luke 7:37-47 NIV)

Rewind. Here's a woman who spreads her legs for money. No man is excluded from her offer. She has learned to strategically coordinate her life around getting the results she needs. Sex for money. And in all probability, sex for livelihood.

But when she finds Jesus, she does something that makes no sense whatsoever. She becomes someone who is entirely unconcerned about any result or outcome. She breaks a jar of perfume over His feet. For her, this act is absolutely sacred, and has no expected result attached to it.

Jesus recognizes the sacred waste. Then He provides the results.

"Therefore, I tell you, her many sins have been forgiven."

She didn't walk into this house with the intent of getting her sins forgiven. She simply knew what she needed to do. Perfume. Waste. Her wages spilled onto the floor of her accusers.

I wish artists would create art without the expectation of any sales.

I wish pastors would preach without the expectation of numerical church growth.

I wish parents would love their children without the expectation of their acceptance into an elite college.

I wish we'd learn the difference between expectation and hope.

I wish we'd all learn to find the sacredness, not in the result, but in the process. Let's work our tails off at the process, making it our sacrament.

But let's learn, possibly for the first honest moment in our lives, to truly leave the results in the more-than-capable hands of Jesus.

THE MAN WHO TINKLED IN CHURCH

For those of you who serve in a church, you will always wrestle with the dream of what your church could become, and the reality of the people who attend it.

That's your struggle.

Your Dream vs. Those People.

When I was a pastor, I was leading worship one morning. I looked into the congregation during a music set, only to notice that a small group of people were quickly moving away from a homeless man. The man had urinated onto the floor, and the people around him were running for cover. I quickly prayed, chopped the last song from the set list, and ran to find a mop.

As I walked off the stage, I distinctly remember God's whisper. "Gary. Do you love your vision for this church more than you love that man?"

We both knew the answer.

Jesus didn't die to save my dreams for His community. He died to save the people who would comprise that community.

There's nothing wrong with having a strong dream for what your church can become. But we live in an era of mega-churches and pastoral rock stars – an era when we could easily become infatuated with size and popularity. So in the middle of this, we must be extremely careful that we don't love our dreams more than our people.

The same people who might pee on our floors.

BURNED OUT OR TIRED?

Just before my youngest daughter went to sleep, she walked down to the couch where I was planted. The remote had become embedded to my hand. She made what would become a life-changing observation. With the innocence and simplicity of a seven year-old, she said, "Dad. It seems like you're always tired or mad."

Burnout was never something I saw coming. But when it hit me, I was absolutely leveled. And the part of burnout I missed had to do with its root cause.

The root cause of burnout had nothing to do with being tired, overworked, or underpaid (although I possessed all three). Burnout happened when I became increasingly unable to inject my unique blend of passion and personality into an environment that could help meet a legitimate need in the world. That's a clinical way of saying that I was a square peg in a round hole.

My dreams were a million miles away from the dreams the position of pastor could provide.

When I was twenty years-old, I was in a band called "Deliverance". Not like the movie. Not like Ned Beatty. Our bass player was Jim Hoffman. One time, we drove to Knoxville, TN to record an album. That was awesome.

Jim Hoffman is an amazing player, and a deep thinker. Recently Jim defined burnout on my blog, in one of his comments.

He said that burnout is "an exhaustion of the will".

I think he's right. And when I look back on the whole experience, I see that a church staff environment can become a breeding ground for burnout.

Here's how it got ahold of me.

I LOST GRACE

I had slowly become someone who was more interested in maintaining the standard than in helping those who couldn't meet it. Everything and

everyone began to frustrate me. Key leaders. Musicians. Graphic Designers. Web guys. Drummers who thought softer meant slower.

Everyone.

I DREAMED OF OTHER OCCUPATIONS

I wondered what it would be like to be a school teacher, a filmmaker, a circuit speaker, a barista, or best of all - an entrepreneur who owned his own business. While those thoughts had run through my mind on some occasions, they were now running through my mind during most occasions.

I DREADED THE END OF VACATIONS

Two days before my vacations ended, I began to get in a bad mood, and would have given anything to just drive to Montana, find a cabin, and live in seclusion for the rest of my days. I think that's also called depression.

I DIDN'T SEE ANYTHING GOOD

I felt like I was putting in my time just to maintain the program, not to change the world. Even when people's lives were being legitimately impacted, I was suspect. Even cynical.

I EXPERIENCED INCREASED MIGRAINES

We all have one prominent physical ailment that exerts itself when our emotions are undernourished. For me, it's always been migraines.

Nothing was going to change at the church. More importantly, nothing was going to change in my heart.

So I resigned.

My first two months out of pastoral ministry were like a poorly scripted film with a heavy Gaussian Blur. My only desire was to make breakfast every morning, then take my daughters to school. There was literally nothing beyond that.

Somewhere during that time, God led me to purchase "Desire" by John Eldredge. For the first time in my life, I could actually discern my own God-given desires outside of the assumptions of pastoral work in a local church. Through an emotional fifteen-month process, I discovered me.

Talk to anyone who's found the exact point where their God-given passions intersect with the world's greatest need, and you won't find burnout at those crossroads. Talk to any leader who's living the exact dream God's given them, while making a difference in the world, and burnout simply isn't present. That's because they're pouring their lives into people and systems, because it's exactly what the want to be doing.

Calling.

Passion.

Desire.

Call it whatever you want, but these people would be doing this exact job for no money at all.

I want to be clear. Burnout is a very real thing. I'm not questioning its existence. I'm questioning its root cause.

And I really don't think the root cause is being overworked and underpaid. I think the primary cause is our inability to marry our deepest God-given passions and desires to a structure or organization where we honestly believe that God can change the world.

Through us.

FEAR AND DREAMS

Our deepest fears stand in stark opposition to our wildest dreams.

It was 3:00am.

Then it was 4:06am.

Then it was 5:23am.

As I continued to toss and turn, pulling the covers on, then throwing them off, I was battling with my deepest fear.

This thing I get to do called Floodgate Productions is my wildest dream ever. But it's also my deepest fear. And during that particular night, I was battling with the fear part of the equation. That night, the specific fear went something like this...

"Gary. You are responsible for figuring out how to feed, not only your own family, but the families of five of your closest friends too." The fear then takes a turn toward the impossibility of growing a business in a recession, especially when your primary clients are churches who are financially strapped.

After battling that fear most of the night, it was apparent that I had lost the battle at our Monday Staff lunch. There, in the middle of the meeting, I emotionally barfed on everyone. The projectile vomit was far-reaching enough to warrant apologies to all involved. Fear, driven by emotional and physical exhaustion, was winning.

But it didn't stay that way.

Fear doesn't have to win. Even when we're at the bottom of our depressive barrel, we have a way out.

I have a friend who totally gets this part of me. He's running his own company, in the same industry, in the same economic climate. So I picked up the phone, and called him. I told him that I didn't need any advice, but that I simply needed to say some things out loud.

I needed to get words out of my heart, and into the air.

You may think that's health and wealth TBN theology. But that's not what I'm talking about. I'm talking about confession. I'm talking about taking words you're feeling in your heart, then choosing the right person to speak them to.

Out loud.

He responded exactly like I knew he would. He was gracious, encouraging, and helped me see clearly.

I hung up the phone, and immediately started dreaming again. I came up with an idea for an IPhone App. I came up with a video idea for a different market. I don't know if these ideas will go anywhere, but that's not the point. The point is that I started dreaming again.

But it was only after I verbalized something that was embarrassing, weak, and stupid to a friend.

Out loud.

> *"Therefore confess your sins to each other and pray*
> *for each other so that you may be healed. The prayer*
> *of a righteous man is powerful and effective."*
>
> (James 5:16 NIV)

I've often viewed this verse in terms of a cause and effect warning – that I won't get healed until I confess. Maybe I need to view it - not as a warning - but as an opportunity. That, if I can find one person to verbalize exactly what's on my heart, I will then experience healing in the deepest corners of my soul.

Our deepest fears stand in stark opposition to our wildest dreams.

But those fears get pummeled when we speak them to one person.

Out loud.

STOP MAKING EXCUSES

I am ready to stop making excuses. You might be, too.

I am ready to stop making excuses for projects that don't meet deadlines, even when I'm the one who set the deadline.

I am ready to stop making excuses with regard to not having enough time. The truth is that I do have enough time. I'm just choosing not to allocate it within a Kingdom priority structure.

I am ready to stop making excuses for other people. I can't own their decisions.

I am ready to stop making excuses for my location at this exact point in my life. Outside forces, as well as my own choices, have intersected at a crossroads called "now". This is where I live – no excuses.

I am ready to stop making excuses for God. He works. He moves. He loves. He's a mystery. And most of the time, I cannot explain His working. I can only explain what He asks of us.

I am ready to stop making excuses about any software program I don't understand. I may never be as knowledgeable as my colleagues, but that's a choice I'm making.

I am ready to stop making excuses for not spending qualitatively better time with my God, with my wife, and with my girls. There is no "I'm too tired" excuse.

I am ready to stop making excuses for any judgmental attitude I carry.

I am ready to stop making excuses.

You might be, too.

WORRY

The alarm was set for 6:15am. I was awake at 5:15am. I'm not a morning person.

Ever.

But this morning, I was lying awake.

Worry. Anxiety. Planning. Deadlines.

My eyes were too heavy to keep them open, but my mind was too riddled to go back to sleep.

So I began peeling away the layers of the Thing that was overtaking my heart. And when I got to the core of what was present in me, I was a bit surprised. I thought it would be the Devil, or a creative idea, or a stupid idea, or a concern about some relationship gone sour. I found none of that.

At the core of my inability to sleep was, of all things, a question. A haunting question. A question that drives me.

And if you've got any artistic bent in you at all, I bet it drives you too.

AM I GONNA BE OKAY?

This question drives almost everything I put my hand to. And I have learned to craft a lifestyle as an affirmative answer to this question.

If my art doesn't sell like I need it to, will I be okay?

If something terrible happens with my non-profit Foundation, will I be okay?

If one of my children ends up on the other side of the spiritual spectrum, will I be okay?

Funny thing about this question. Jesus never asked it.

Why in the world would Jesus ever need to ask an absurd question like that? His relationship with His Father was too trusting. He always knew He'd be okay.

Even on a cross.

If Jesus set His alarm clock for 6:15am, and He woke up at 5:15am with some huge question on His heart – the kind of question that would motivate Him to act during His coming day – I think that question would not be "Am I gonna be okay?" I think it would be a different question altogether.

Is the world gonna be okay?

That's the question Jesus would ask. It's the question that seemed to haunt Jesus as He walked and talked with those who chose to follow Him.

I wonder what kinds of things we would all be compelled to do today if our primary question changed from my question to Jesus' question?

CREATING ART OR CREATING IDOLS?

The art we create can give us great joy.

The art we create can provide peace.

The art we create can demand our entire focus, over a long period of time.

The art we create can be frustrating.

The art we create can point toward something deeper, stir something uncomfortable, or introduce something unknown.

But there's one thing our art cannot create. And we need to be extremely careful here. The art we create cannot be our salvation. And when we ask our art to save us in any manner, we've created something more than art.

We've created an idol.

Artists know that they're crossed the line into idolatry when they attribute salvation to their art.

Do you remember the story of the Golden Calf in the Exodus narrative? The people grew weary of a God who refused to show up, so they created something physical. When any of us create art, we're trying to bring something invisible into existence. But they took it a step further. They gave the Golden Calf credit for liberating them from bondage in Egypt. In so doing, they worshipped the created rather than the Creator, attributing their salvation to a calf, not to an all-saving God.

> So all the people took off their earrings and brought them to
> Aaron. He took what they handed him and made it into an idol
> cast in the shape of a calf, fashioning it with a tool. Then they said,
> "These are your gods, Israel, who brought you up out of Egypt."
>
> (Exodus 32:3-4)

As artists, we walk fearfully close to this line with every piece of art we create. It's so easy to jump from God-worship to art-worship. Whenever I

create a piece of art, there's always something in my heart that comes alive. I can feel it in my core. And there's nothing wrong with that feeling.

But the giver of the life I feel isn't the art I created, nor is it the creative process I submitted to. The Giver of the life in my heart is the Giver of all life. And I bow down to artistic idols when I thank the art for giving me life.

Can our art be involved in salvation? Absolutely. God uses art in salvation every day. But can our art become salvation? Not a chance. The price paid for our saving was far more than a video, or a painting, or a sculpture, or a song.

Creativity

It's morning, and my wife has just asked me how my late night work session went. Feeling accountable, I say "Good. It was good." I know what the next question will be.

INTRODUCTION TO CREATIVITY

Written by Dave Wilkins

"Were you productive?"

A simple question really. But I tend to complicate things. "Uh, yeah. I got some good work done... a lot of research." She gives me a knowing look. She has my number. By research I mean the desperate search for inspiration.

Though I am not a lazy person, I tend to procrastinate doing any real work until the margin for completion becomes so small, I'm forced to work in a hard and focussed manner. I'm probably alone in this. It's hard to imagine anyone else going through this cycle of unnecessary torment.

It's probably just me.

Once, I was given a beautiful opportunity. Upon seeing my looming deadline, as well as the scarcity of finished work for a large art project, my wife packed up the kids for the weekend, and left me to complete the project. A beautiful opportunity really. All my excuses. Gone. Beautiful. Really.

Crap.

I was given what I had always dreamed about. I was given complete space and freedom to explore. Yet I kept wanting to "check the map." I think I was afraid of taking false steps. As the weekend came to a close, I ended up painting over several canvases three times before bringing them into a finished form. And I'm glad I did. They ended up having more character that way.

And so did I.

Inspiration is a very good and needed thing, but it is no substitute for hard work. Most artists I know are not at a loss for inspiration. Instead they're fearful of what will, or won't flow out of them once they set about getting to work. I know that I need outside inspiration, but I have inflated

its importance in the creative process. As a creative person, it is my duty to create at least as much art as I consume. Hopefully more.

Consuming art can change me. Creating art can change the world.

And unfortunately, the biggest problems I face in the creative process stem from the fact that I have bought into two myths about creativity.

The first myth is that creativity is a sort of feeling. It's a mood to be summoned from the ether. It's something of which I am at its mercy. But creativity is a practice. It's an action. To bring it into being, you must act as if it's already there. It's a lot like love. You may not always feel it, but the more you act upon it, the more you will experience it.

The second myth is the idea that creativity is not a very serious business. While it's true that it can be fun and quirky and nebulous, this doesn't mean that it isn't a matter of extreme importance. When I am dismissive of my art, I am denying the message that God has put on my heart, and the voice He has given me. I don't think He takes that issue lightly.

The more seriously I dig in, and try to reveal the truth, the more resistance I seem to come up against. But the outcome is always very rewarding. I don't think that this is a coincidence. When we as artists put a face on truth, it can be a very dangerous business.

But the world desperately needs it.

Much of this is probably all my own neurosis. It's probably not relevant to anyone else. As I write this, it's now 1:30am.

The deadline is here. And I've waited until the last moment. I'm wondering what the other chapter introduction authors have written. But it's probably just my own issue.

It's probably just me.

CREATIVE BLOCKS

For the first forty years of my life, someone other than me told me what art to create. Pastors and ministry leaders told me their ideas. I responded by creating articles and music and video and print pieces. They became inspired, and they handed me their inspiration.

But starting at year forty-one, I've been the guy who's inspired.

Or not.

Our client work demands that our Creative Team suggests artistic concepts and elements to potential clients. With regularity, they give us a general message they have, but usually end with, "I don't know what I want until I see it." I used to hate that, but now take it as a personal challenge.

Our church video resources demand that we consistently come up with short-film ideas, carefully crafted scripts, new shot angles, believable actors, and cutting edge post-production techniques.

So in order to make payroll, inspiration must always be there. Anything less, and we close the doors. So, as you might imagine, I feel a constant pressure to be inspired.

The great news is that God is always whispering artistic inspiration into my ear. I'm just learning what to listen for.

I LISTEN TO MY PASSIONS

God gives so much artistic inspiration when I listen hard to the things I'm most passionate about. Worship, church, leadership, and being a good husband and father. I have strong opinions about those things, and I find that I can become easily inspired to create art when I pay attention to them.

I LISTEN TO MY FRUSTRATIONS

If you watch our short-films, you'll see that many of them start with a point of frustration, then speak truth into that situation. Mainly, I'm frustrated with Christians who are more concerned with believing right, than they

are living gracefully. I'm also very frustrated with the fact that we have taken worship, and somehow turned it into a specific musical genre. Those frustrations launch me into my art.

I LISTEN TO MY BROKENNESS

The bulk of this makes me look pretty special – like I've got the answers, and I'm sharing them with you. But I'm probably more broken than you'll ever be – from my own stupid choices. The only thing that makes me special is the label God has bestowed on me – the label of Son. Everything else reeks of pride, insecurity, and an inability to fully submit. Much of my art is created out of a willingness to name my own brokenness, then create art that reflects that brutal truth.

I LISTEN TO COUNSEL OF THE WISE

Reading the Bible is key to my inspiration. But so is reading my favorite authors. There are three authors who, when they write a new book, I one-click purchase without even thinking. They rattle me, they frustrate me, they challenge me, and they inspire me to create art. I curse at them, and revere them in the same breath. I also listen to the good people I work with – creative, administrative, or other. They all inspire me.

I assume you've made it this far because you're interested in some practical ways of becoming inspired to create the art you love. And while I don't have any lock on the process, I just know what works for me. As I sit in my office, praying for inspiration, I regularly revisit those four items.

FEAR AND THE CREATIVE PROCESS

The tall man who wrote the Introductions to the Sections about Authority and Purpose also wrote the words below. When I read these words, I immediately knew that they needed to be published in this book.

As you read Scott's internal cycle, I think you should pause at each word, and just think about what he's saying.

About what God might be saying to you.

Sometimes when I get the urge to create something, I go through an arduous and ridiculous internal cycle. The cycle goes like this:

Inspiration.

Idea.

Ignore it.

Idea returns.

Like it.

Dismiss it.

Idea returns.

Love it.

Get excited.

Start sketching.

Imagine the finished product.

Imagine people loving it.

Yes, it will be hard - But it will be worth it.

Look to software and bookshelf for reassurance.

Open a blank Pages document.

Accept imaginary congratulations.

Type first sentence and a few bullet points.

Take a break.

Wonder if Pulitzer Prize includes a trophy.

How heavy is the trophy?

Feel guilty for presuming success.

Imagine people loathing finished product.

Get scared.

Imagine people loathing its creator.

Get scared.

Imagine people ignoring finished product.

Get scared.

Imagine people ignoring its creator.

Get scared.

Curse.

Revisit napkin sketch.

Explain away its promise.

Amplify its weaknesses.

Scrap it.

Breathe easy as the fear subsides.

Check Twitter to see if anyone noticed or inquired about me.

Check RSS feeds to see what everyone else made today.

Create something safe.

Publish it.

Facebook it.

Sigh.

Resign to live another day as unimpressed as those who viewed my safe work, and moved on.

Am I alone in this?

BREAKING THE RULES

When I was fifteen, my best friend was Nick. I was two years older than Nick, and I could tell him to do anything, and he would. It went the other way too – I'd follow him anywhere.

In my church, we had Sunday night services. The important people in the church must have thought that one service in the morning wasn't enough, so they'd do the same thing on Sunday night, but with a different sermon. My parents thought it was very important to attend the Sunday night services, and would often tell me that we needed to go and "support the church".

The pastor was preaching on the evils of poker, or drinking sparkling apple cider, or dancing, or something that I don't remember. We sat in a large room that everyone called "the sanctuary". It was built during the tenure of the previous pastor because the church had grown so much. That pastor had died, and a new pastor had replaced him. The room was big enough to hold 1,000 people comfortably.

There were fifty people in the sanctuary that night.

My father was on the Deacon Board, which was a group of people who made important decisions in the church. As a part of his responsibilities, he was given a master key that opened every door in the church.

It even opened the door to the baptistery.

Get the key, and get into a place that only important people could get into.

The pastor was preaching, and Nick and I decided to give the key a try. We went backstage, where we found the door to the baptistery. We used the magic key to open the magic door, which led to a magic flight of stairs, which led into magic changing rooms which led into the magic pool where people were baptized. It was dark, and no one was there that night, and we could still hear the pastor preaching off in the distance.

My friend Nick saw a trap door in the ceiling. For two teenage boys in the middle of a rule-breaking adventure, that trap door felt like the back

of C.S. Lewis' wardrobe closet. To not open it would have been a sin of omission. We moved a chair into place, and stood on it so we could reach the door. I have to tell you – I felt like I was living inside the biggest adventure of my fifteen years. Nick was just smiling.

A ladder came down to us – the kind of ladder that had weights on the other end, so it came down slowly. We climbed the ladder easily, and it led us into a large dark room with speakers. I'm not kidding – there were speakers everywhere. It was the church's sound system, housed in a huge room three stories above where the pastor was preaching and the people were listening.

The people weren't really listening. They were nodding and smiling, and mumbling, "Hmmn", as if to say, "Yes pastor. I agree with what you're saying about the sparkling cider issue facing our Nation."

I don't think many people were listening, because Nick and I could see them. The speakers faced a wall of brown fabric – the kind of fabric that you can see out of, but that the people in the sanctuary couldn't see into. It was a kind of mesh. So Nick and I stood at the edge of the brown fabric wall, and looked down from three stories at the fifty or so people in the room.

Teenage boys become brave and courageous when they realize that no one can see them.

So as the pastor continued preaching and pointing at people, I did my best pigeon imitation. You know that "coo" sound they make? I did that, at an average volume. A couple sitting near the front looked up quickly. We laughed hysterically, but not out loud. When you can't laugh out loud at something that's really funny, you laugh even harder. You snort a little.

After we regained ourselves and could breathe again, Nick dared me to make the "coo" sound once more. So I did. But this time, I was louder. Much of the congregation looked up. They must have thought there was a pigeon in the room somewhere.

We were really having fun now. We were making people look up at something they couldn't figure out. The pastor never stopped preaching, and never heard us. I promise I peed in my pants a little. Tears began to roll down Nick's face because he was quietly laughing so hard.

We never got caught, and no one ever found out that we were the pigeons that night. We would visit that room time and time again during the next four years. Nick and I took my brother Craig up there once. He really enjoyed himself.

Stories like this make me wonder.

They make me wonder why the really great stuff happens when someone breaks the rules? It seems like those are the stories we remember – the ones when someone does something they shouldn't do.

Abraham Lincoln changed the face of American slavery because he broke the rules. Martin Luther gave birth to a new way of understanding and experiencing the Bible and the Church because he broke the rules, and then pinned those rules to a door at Wittenburg. Jesus himself broke a myriad of religious rules in first-century Israel, and gave us a new way to experience what he called "death". Then subsequently, what He called "life".

We are Christ-followers because Christ didn't follow.

I'm not saying that my story is akin to Lincoln, or Luther, or Jesus. But as I'm writing this, I find myself wondering what rules I'm supposed to be breaking these days.

Artistic rules. Formulas-to-live-by rules. Design rules. Distribution rules.

I pray that the narratives we're creating today are as compelling and adventurous as making pigeon noises from three stories high. I pray that we laugh until we pee (a little bit). But I pray that our impact and our scope are far greater.

And I pray that we're willing to break some rules along the way.

DISCONTENT

There's never a morning when I wake up feeling content. Ever.

I may feel grateful, or lucky, or blessed, or excited, or happy, or joyful. I may feel stressed, or anxious, or worried, or dread, or fear.

But I never feel content.

I woke up this morning in a mountain cabin. I've come to this cabin, at this time, to complete this book. There's freshly fallen snow all around me, and the now-breaking-through sun beckons me to join in the beauty that's forming just outside the sliding glass doors. At some point soon, I'll accept his invitation. But not yet.

The discontentment won't allow me to.

I think discontentment is a good thing. There is beauty in this sensation that something in our lives is not yet finished - that we need to write something, or read something, or pray something, or draw something, or paint something, or shoot something, or sing something.

And rather than fight against it, I wish we'd learn to embrace it.

I'm learning that the not-yet-done feeling in my gut is driving me toward something artistic, toward something creative. It moves me away from filling my days and my nights with mere routine, and into a space where something new has the potential to move from idea to action to creation.

Ten minutes ago, there were no words on this page. Discontentment is inspiring her work in me.

The very nature of God's redemptive work echoes these timeless truths deep inside of us. We have been fully redeemed in Christ, yet all creation groans for redemption. We have been made completely holy before God, yet we are being made holy every day. The Kingdom has come in Christ, and yet we wait for the Kingdom to come.

Artists must learn to listen intently to the voice of their own discontentment, for she is whispering a message to them.

She is calling them to create.

She is inspiring artists to fashion something into existence that's better, or deeper, or more beautiful, or more lovely, or more sorrowful, or more uplifting, or more exacting, or more abstract. She's calling you, even in moments like this, to create something new and fresh and visible.

I'm putting on my shoes now, readying myself for a walk. I'll experience the new and fresh and visible handiwork of a God who's been creating it all for His glory. My jaw will drop when I arrive at the now-frozen lake.

But after my walk, I'll come back to the cabin, pick up my writing machine again, open up a blank page, and allow discontentment to inspire me.

She's not an attractive dance partner, but she's a beautiful dancer.

BAD DREAMS

Artists and leaders have something in common. Their minds are always racing with what could be. There is always a new idea, always a potentially better path, always a creative task that could change the landscape for the viewer.

Artists and leaders are dreamers.

Artists live out their dreams within the context of their art. With every new piece of art, they have hope that something will change, or be seen in a new or better way. They hope that people will laugh, or cry, or be inspired to change their world.

Leaders live out their dreams within the context of their organizations. With every new idea, or path, or program, they have the hope that something will change, or be seen in a new or better way. They hope that people will laugh, or cry, or be inspired to change their world.

Dreams are good. And dreaming is healthy.

But there is a point where both the artist and the leader have bad dreams. That point usually happens when they allow their own expectations to become part of their dreams.

And when artists and leaders begin to attach expectations to their dreams, they create nightmares.

The artist writes a song, and fully expects it to get picked up by a record label. She's taken a dream and attached an expectation to it. When she's not picked up by a record label, she becomes angry and resentful at God. Depressive seasons in the life of any artist can mostly be traced to placing expectations on God or culture for the impact of their art.

The pastor goes to the Pastor's Conference, and sees how church can be done differently. He gives birth to a dream, and it's deeply implanted in his heart. He comes back to his own unique congregation, and begins enacting his dream. But he unknowingly attaches the expectation of rapid growth onto that dream. The church grows only marginally, and the pastor is disillusioned.

There is a plethora of dream language in today's culture, and today's church. Here's what I think about dreams. I don't think God gives dreams to us.

I think He loans them to us.

I don't think the dreams inside our hearts are ours to own. They are only ours to steward. My Dream is a misnomer.

Artists must become people who are content with attaching flesh onto the skeletons of their dreams, but who have no control over the growth or expansion of the body.

Humans have no control over their dream outcomes. We just don't. I think we'd dismiss a bucketload of pain and suffering from our lives if we simply gave in to that truth.

The primary task of the artist - today and every day - is to dive more deeply into the river of unending love with the Dream Giver. He will grow us. He will continue to give us dreams.

And we learn - mostly through tears and pain - that anything that happens as a result of our dreams is completely His to create, to own, and to receive glory for.

Church

When I sit down to write about the Church, I'd be lying if I said it was easy. Even now there are a million different directions fighting for first place in my head. But I think oftentimes...

INTRODUCTION TO CHURCH

Written by Katie Strandlund

...we write what we ourselves need to hear - like putting pen to paper or fingers to keys somehow makes our words more true.

And we just need them to be true.

It is from that place of writing that I most often approach the relationship between art and the Church.

I am an artist. I have worked in churches. I have also been hurt by people who work in churches. I have spent plenty of time bitter at the church as a result.

And frustrated.

Frustrated by the hype. By the noise. By the "Christian celebrity" epidemic. By flashy production. By in-authenticity. One size fits all programs. And feel good mission work. Yes, I spend entirely way too much time judging the Church and those in churches.

As a result there have been times I wanted to give up on the Church. Times when I wished (and if I'm honest times I still do wish) I didn't feel like God was calling me to the Church. Because it seems life would be so much easier that way.

I'm not going to plead with you not to give up on the Church. And I think that means not giving up on churches either. I get it. Working for a church isn't easy. Serving day in and day out can be exhausting. Relationships get messy because imperfect people who work in those churches can, and probably will, hurt you.

Instead, I am going to plead with you not to give up on your gifts. On your art. You have been uniquely designed to create. I'm pleading with you not to let the rejection or frustration you feel from the Church stop you from faithfully using your gifts. Be who God designed you to be, not worrying about what you think the Church or the world wants you to be.

What they need is for you to be a faithful witness as you live out your calling as an artist.

We have an opportunity to tell the Story of One who is perfect. A perfection that covers the fact that we aren't perfect and life isn't perfect and the Church isn't perfect. A Story that is so much bigger than our churches. A Story that reaches from China to Thailand to Uganda. To Haiti, Guatemala, and Russia. In all of those places, through all of those languages, art can communicate the truth and beauty of grace. It can reveal brokenness that it may be healed. It can facilitate community. It can open a new window through which to view the world. And in doing so, art can facilitate relationship and change. That is the power of your art. That is the power of the Story you tell through your art. And that power and Story is unchanging no matter where you create art.

Knowing that Story.

Telling that Story.

Living out that Story.

That is being the Church. A Church that supports one another and holds each other accountable with love and compassion. One that encourages and challenges us all. That embodies brokenness and grace in action.

Never stop sharing that beautiful Story through your art.

THE BEAST

The Beast hasn't always looked like this.

There was a time, in what now seems like eternities past, when the Beast was beautiful. A vivid beauty. Riveting. Borderline wild, yet with a soft and compelling pattern of speech, using words that were gentle and inviting. People would travel long distances to see and experience the glory he possessed.

He was inspirational.

At the core, those who knew him told stories of the inspiration he offered all people. Inspiration to live. Inspiration to dream. Inspiration to stand with the crowd, or without it. Inspiration to change. Inspiration to die. Simply being within a stone's throw of his forceful splendor inspired people to love deeply, and be loved willingly.

The problem with this beautiful creature became quickly evident, however. There was a Secret that no one knew. The creature would take on the beauty, or the hideousness, of the quality of food he was fed. With the right people around him, he ate well. The food was good, and he became even more beautiful. But when people fed him the wrong food, he began to lose his outer beauty.

This was the Secret.

The years passed, and more and more people continued to feed him food that was unhealthy and addictive. He even became less and less mobile, and would soon stop walking altogether, simply because he could no longer move with ease. Finally, he could no longer move at all.

Feeding the Beast became popular in those days. Feeders were generally people who were entirely unaware of the Secret. They simply saw him as an unfortunate creature who was hungry - as someone needing to eat. Anything.

Years continued to pass, and as you might imagine, he became unsightly. Ugly, to be honest - not only to the people who continued to feed him, but to people who would simply pass by and stare. There were stories about

his once famous attractiveness, but those stories began to pass away with each passing generation of feeders.

The Beast hasn't always looked like this. But today he does.

There's an interesting tone in the voice of passers by. Often, you'll hear someone speak of his physical appearance by resolving, "That's just who he is", almost as if he's pathetic and untouchable. They feel sorry for him, as they throw him a morsel of something that will only make him hungrier in a few moments.

But there are growing numbers of people who see. These are people who, as they pass by, purposely and willingly take a step closer to the Beast. Then another. And another. There are also a small group of people who once fed the Beast poor food, but who are now resolving to restore his original attractiveness by feeding him the highest quality fare, as if from the exquisite menu of a master chef.

These people are beginning to see the Mystery that lies beneath the identity of the Beast – a Mystery lost in ages past, but being resurrected today. Wherever there is the presence of the Secret, there is also the stronger presence of the Mystery. The Mystery is profound, incomprehensible, and full of hope. The Mystery changes everything..

A waterfall in a paper cup.

The Beast only changed on the outside.

That's the Mystery. Only on the outside.

He is not, and never was, a Beast. On the inside, he is as beautiful as he was when he was first created. There is an inherent attractiveness about him that will not, and cannot change him.

There is still beauty.

Astonishing beauty.

Beauty that takes your breath away with one accidental glance.

And for those brave enough to step close enough to him, they will hear a faint, but present whisper. It may be garbled. Muffled. A whisper in the middle of the battlefield.

But it's there.

"Bring me back. Restore my beauty."

He whispers it over and over again.

He does not explain to anyone the Secret of the food offerings. He does not demand to be fed the right food. And He certainly does not solve, or even acknowledge, the Mystery.

He invites.

And at times, He pleads.

And he whispers to all who would draw near, "Bring me back. I cannot do this on my own."

I wrote this short-story to compare the Christian Church to a beast. I would never call the Bride of Christ a beast. But people can turn her into something that God never intended. This tale is meant to chronicle the journey the church has taken in the past 2000 years.

The Secret of the Food Offerings Is my way of illustrating that the church becomes whoever joins her. And if people attend a church only for what they receive, then the church becomes selfish. Once this happens, the church loses the beauty she was created for.

At least on the outside.

But there's a turn in the story. The turn happens when people begin to see the Mystery. The Mystery is my way of illustrating the fact that the Church has never abandoned her beauty on the inside. She is still extraordinary.

And she beckons once more for sinners and saints to draw near, and to help restore her to her original beauty.

So a world can once again pass by and experience the Spirit she emanates.

It might be enlightening to read back over the short story, now that you know the symbolism.

WHO CAN'T ATTEND YOUR CHURCH?

"On reaching Jerusalem, Jesus entered the temple courts and
began driving out those who were buying and selling there.
He overturned the tables of the money changers and the
benches of those selling doves, and would not allow anyone
to carry merchandise through the temple courts."

"And as he taught them, he said, 'Is it not written: My
house will be called a house of prayer for all nations?
But you have made it a den of robbers.'"

(Matthew 1:12-13 NIV)

Jesus went to the temple courts, saw what was going on in the name of God, and got really, really angry. It was a bit of tirade, to be honest.

The classic interpretation suggests that people were buying and selling stuff in God's house, and that's not okay. So for churches that have a coffee bar, Jesus might toss the latte machine out the window, and whip the student volunteers who are running it.

I wonder if something else is going on here, and I wonder if the Old Testament passage Jesus quotes informs our understanding? The passage Jesus quotes is Isaiah 56.

"To the eunuchs who keep my Sabbaths, who choose what pleases me
and hold fast to my covenant - to them I will give within my temple
and its walls a memorial and a name better than sons and daughters.
I will give them an everlasting name that will endure forever."

(Isaiah 56:4-5 NIV)

In these verses, Isaiah addresses eunuchs - a group of men we can all relate to.

He says that, if these people who are ceremonially incomplete actually pursue God and honor Him by keeping the Sabbath, then God will give them an everlasting name within the temple. He's promising to change their character

and their status. Those who are considered ceremonially incomplete or unclean, but who love God and are pursuing Him, are not out.

They're in.

"And foreigners who bind themselves to the LORD to minister to him, to love the name of the LORD. and to be his servants, all who keep the Sabbath without desecrating it and who hold fast to my covenant - these I will bring to my holy mountain and give them joy in my house of prayer. Their burnt offerings and sacrifices will be accepted on my altar."

(Isaiah 56:6-7 NIV)

After addressing eunuchs, Isaiah addresses the non-Israelite. He basically says the same thing, adding that they will find joy in the House of Prayer. And once again those who are considered nationally unclean, but who love God and are pursuing Him, are not out.

They're in.

Finally, Isaiah ends his thoughts.

"For My house will be called a House of Prayer for all nations."

(Isaiah 56:7 NIV)

All nations.

Time travel forward to the temple, and to Jesus, and to the whips, and to the tirade.

The mention of selling doves is important. Because of God's grace and kindness, this was the only sacrifice God required from the poorest of the poor. Not a fattened lamb, or bull, or scapegoat.

The mention of Temple courts is important, too. The courts of the Temple were where everyone was invited to come, pray, and experience God. Nationality or social status was never meant to exclude people.

Even poor people.

But because of a price-fixing issue, the poor were actually excluded from experiencing atonement - given by sacrificing a dove - because they couldn't afford the dove. Even more importantly, they became excluded from the Grand Invitation of becoming sons and daughters.

Do you see the heart of God? From the beginning, God's heart was for Israel to become a light to the world, not an exclusive club.

Lights include.

Clubs exclude.

And when well-meaning people block that invitation, God gets really, really angry. And I think that's why the religious leaders plotted to kill Jesus.

Their club was being compromised.

God's heart is for Christ's Church to become a light to the world, not an exclusive club. And when well-meaning people block that invitation, God gets really, really angry.

Jesus did nothing by accident, so it was certainly no accident that, four days before opening the way for everyone through the cross, He turned the tables on people who had blocked that way.

When our churches invite anyone to attend, we really need to mean that. God's heart is, and has always been, for people who are willing to experience Him on His terms - even if they're not sure what that means.

All are invited to come, learn, grow, and live.

May our practices never, ever block that doorway.

EMOTIONAL UPRISINGS

Visit AnyChurch, in AnyCity, at AnyTime. If that church uses art, you'll most likely see that art being used in one of two ways. The first is obvious. The second, not so much.

ART CAN HELP COMMUNICATE TRUTH

For men and women who enjoy teaching, this comes naturally. They employ art as a communication tool. When a song lyrically fits the sermon, art is being used to communicate truth. When a video bumper is played just before a sermon, art is being used to communicate truth. Anytime anyone tells a masterfully crafted story, art is being used in this way.

ART CAN HELP IGNITE UNRESOLVED CRAVINGS

Art not only communicates truth. It also creates emotional uprisings. In this way, art opens, then resolves nothing.

Many churches have never considered giving an entire congregation the chance to experience emotional uprisings. Many church leaders are uncomfortable if the final fill-in is left unfilled. It seems far safer to give people tips and techniques and formulas alone, than to give them a license to touch a Mystery.

Yet for those who might consider allowing art to stir intense emotional uprisings, they will discover the solemn beauty of art as an instigating tool in the hands of the Potter. It gives people the chance to sit, to contemplate, and to experience a wider variety of emotions.

Rather than causing us to leave church with a smile, what if God's will is for us to sit in our own personal pond of holy agitation the whole morning, and actually experience the ache of seeing no way out? And what if He wants to use a painting or a sculpture or a dance or a drama or a video to push us headlong into that pool? The Psalmist declares that the Shepherd "...makes me lie down" (Psalm 23 NIV). Sometimes, God has to force us to lie down - a forcing that gives us eyes to see the green pasture that surrounds us.

What if your art could become a tool of the Shepherd's forcing?

At my church, we have a Good Friday service. Participants are invited to walk into a room filled with art - video, music, paintings, and symbols. We're given an unlit candle. We're also given a printed handout, designed to loosely guide us through the stations of the cross. It doesn't matter how fast or slow we progress. We can stop, pray, experience, weep. No one is leading, no one is on the stage, and no one is speaking. Finally, most of us light the candle and place it at the cross in the center of the dimly lit room.

At the end of the experience, we ache. The closest thing we feel to joy is probably thankfulness, but even that pales in comparison to the unresolved anguish in our hearts.

Art used in this manner reminds me that not everything needs to be resolved for it to be beautiful. It also makes me think that we actually force resolutions and outcomes on people, because closure makes us feel better about everything. But the tragedy with always providing closure, is that real life hardly ever provides it.

Paintings displayed at the right location.

Sculptures that people are forced to walk past, even to touch.

A beautifully designed table during the Eucharist.

Images on the screen, with an underscore of silence.

Stories told beautifully.

Smells of smoke, or roses, or bread.

Music that drops dead with dynamic, and never rises again.

Lighting that helps people focus on the beauty found in the moment.

So what if art can provide an opening, not only a closing? What if, every week your church had the ability to drop a beautiful piece of art into the worship experience, and to just let it sit there? Using art like this isn't the opposite of using art to communicate truth.

It's actually the beautiful sister many of us have never met.

Artists must work hard during the week at setting the table. But then, churches must allow the masses to feast. Because no matter what the size of your church, your worship experience can be so much more than some music.

And a lecture.

MARKETING OR LYING?

Last semester, my oldest daughter worked on a presentation for her College English Class about truth in advertising. She'd seen the television commercial with Paris Hilton eating the Carl's Jr. burger, and was trying to reconcile the implied promise being made, with the purchase of a burger. She asked me simply, "Dad. When is it marketing, and when is it lying?"

Great question.

Great question for churches.

When is it marketing, and when is it lying?

I think churches could learn to create a rhythm of communal life where three questions are consistently asked about any piece of internal or external publicity, displayed anywhere on behalf of the church.

THE ADJECTIVE QUESTION

The first question to ask has to do with adjectives. The primary (and most courageous) question to ask has to do with grammar.

Are we really using accurate adjectives to describe the object of our design?

If a church program isn't amazing, then don't call it that. Or transformational. Or inspiring. Or successful. If it's not really a place that most people call "home", then don't use the slogan "a place to call home". There's nothing wrong with using any of these words or phrases, but churches need to make sure they're accurately describing what's really happening, not what they only hope is happening. Words matter.

THE FUTURE VS. REALITY QUESTION

The next question has to do with future goals and current realities. The Future vs. Reality Question is extremely important, especially when the copy writer is also a visionary leader.

Are we advertising a future goal as if it were a current reality?

By far the most popular phrase that falls into this category is "life-changing". Does every worship service have the potential to be life-changing? Yes. But in the normal life of a church, is every worship service really "life-changing"? Probably not. These services have the potential to change someone's life over the long haul, but that's a future hope, and shouldn't be advertised as a current norm that happens to everyone, all the time.

Another popular phrase is "reaching the world for Christ". Churches need to be honest about this and ask if they're currently reaching the world for Christ, or is it something they're striving toward?

THE COMPARISON QUESTION

Finally, church leaders and artists need to ask the comparison question all day, every day.

Are we building up our own church by tearing down others?

There's a classic example of this type of marketing "Tired of church as usual?" I actually used that in a direct mailer ten years ago, and I still see it used all the time in my community. I also see it on North American church websites.

When I used that phrase, I was really saying that we had a rockin' band with a crankin' sound system, and that we valued relationships over programs. Oh - and that we preached topically. I should have just stated those things, instead of comparing my church with other churches.

As a personal aside - I was the most arrogant and prideful pastor you'd ever hope to meet, and our marketing campaigns proved it. I was guilty of building up by tearing down every week, for years. My wife told me to stop doing it, but I didn't listen.

WHY DOES ALL THIS MATTER SO MUCH?

This stuff matters because God doesn't need exaggerated marketing or false publicity. It matters because God is not a liar. And it matters because of the door-hanger Bill holds in his hand.

Bill and Kelly have been arguing more than normal. They've mentioned the possibility of counseling, but neither wants to make that call. Their two young boys are beginning to act out. Tommy is starting to withdraw and become more isolated. Brandon has been reprimanded twice in the last week by his second grade teacher. Kelly knows the missed call from the teacher was made to set up a parent conference.

And Bill holds the door-hanger advertisement for your church in his hand.

What's the most honest wording your church could put on that door-hanger? Not in the future, but right now. How can your church not bait-and-switch Bill and his family, sending them even farther into skepticism? Describe your church as it really is. Can you write the copy in such a way that gives hope, without making empty promises?

Because Bill's family is real, and they live everywhere.

Marriage gets tough. But you're not alone.

That's what I'd write for my church. Yours will look different.

I pray our churches have the courage to be honest about the words we put in front of the blessed people who don't have any idea who we are.

Or who He is.

WHEN EVERYTHING IS BOLD

I was in New York City for Thanksgiving 2010, and we stayed in Times Square. If you've ever experienced that, you know how insane it is. There was amazing advertising everywhere, all plastered onto the sides of billboards and buildings. Every year, large companies spend millions of dollars to get their name and their message in front of the people who walk by. I was one of those people.

And one week later, I couldn't remember a single advertisement.

It's because each one was bold. Each one had flashing lights and big statements and sex and logos and an animated model inviting us to look at her. Everything was so overwhelmingly bold.

So nothing stood out.

I think this principle has an important application in the way we program for our church services.

I've always been a proponent of allowing people to breathe in church services. I've always felt like there needs to be a bottomed out moment during every church service – a moment where the lights, the camera, and the action seem to simply disappear. From a production point of view, we know these things never disappear.

But great production people can make it feel like they do.

Why is this so important? Because when everything in a church service is huge, or life changing, or loud, or happy-clappy - when everything stands out, then nothing stands out. When we program our services this way, we lose the potential impact.

It can feel a lot like the whole service is a cymbal that's clanging abusively.

And so that bottomed out moment becomes absolutely critical for the hearts of real people. In the best case, two things happen during these non-bolded moments.

First, people are given the chance to exhale, or to experience silence, or to simply be in a place where no one needs anything from them. There is no other moment during their entire week when this occurs.

Second, people are directed toward some communion with God. They're pointed toward a prayer, a word from Scripture, or a bite of bread or a sip of wine.

Pastors and Program Directors and Artists at churches can easily become scared of these moments for fear that people might become bored. But isn't that really a heart issue between the potentially bored person and God? What about the other 90% of people who crave a quiet moment in the midst of their own personal chaos?

When everything is bold in a church service, then nothing is bold in a church service.

May this play out uniquely and beautifully in your unique church.

Leadership

I have two sons. When they were younger, I used to volunteer at school grading papers, cutting things out of construction paper and explaining to little Johnny that, while booger was a word...

INTRODUCTION TO LEADERSHIP

Written by Pat Callahan

...and that I did indeed know how to spell it, I didn't think that the teacher wanted him to write a poem called "My Booger is Bigger."

And while I enjoyed my time working in their classes, every time I was there I harbored a secret fear that one day the teacher would be called away on some vague emergency, leaving me alone and in charge.

Secret fears.

Leading artists has inherent challenges that can strike fear into the heart of any leader. I have these secret fears.

Artists can be flaky, flighty, irresponsible and prone to over reacting. I know because I am one. Our temperament can be a mystery to the average left-brained Type-A leader. But it's also true that when healthy leaders create healthy environments that allow artists to be nurtured and mentored, those same flaky, flighty, overly-emotional artists thrive and create art that communicates truth through beauty in a way that moves people to their very core.

Leading artists requires that leaders live in the tension between accepting artists where they are, while challenging them to realize all that they can become as healthy individuals in healthy environments.

I probably have more questions than answers about leading artists. In fact, Gary could have asked a host of other, more capable leaders to write the forward to this chapter. The fact that none of them said yes probably has a lot to do with why you're reading what I wrote, rather than a cool leadership acrostic by John Maxwell or Rick Warren.

Plus I took him out for lunch and a movie on his birthday. And paid for everything.

Seriously, I strive to lead people the way I want to be led. I lead them with confidence, patience, encouragement, enthusiasm, positivity, love and an extra measure of grace.

I can be affected by my past exposures to poor leadership only to the extent that I allow myself to be affected by them. I can choose to be the leader I want to be, sometimes by becoming the leader I wish others would have been to me.

I believe much of leadership is the art of getting people to play well with others while achieving some greater good. I believe that playing well with others is a lot more fun than working well with others. People having fun will always get more done.

If leading artists is akin to herding cats, then I will always be a more effective leader if I keep a can of tuna in one pocket, and a bag of catnip in the other. One has to do with positive motivation; the other with developing an environment in which people delight.

So how do we help people experience delight as they create art for their churches, and their worlds?

FRANK

I was having breakfast with a good friend. He works for a non-profit ministry that equips and encourages professional athletes. Halfway through the pancakes and perfectly cooked bacon, an older gentleman approached the table, shook my friend's hand as if he knew him, and asked if he could sit down.

The man's name is Frank.

Have you ever just sat in the presence of Godly wisdom, and you knew it within five minutes of meeting the person? That's what I felt with Frank.

Frank was on the original Board of the Fellowship of Christian Athletes (FCA), and served on that board with Tom Landry (Hall of Fame Coach of the Dallas Cowboys). Frank's voice was humble, and his stories were amazing.

As I get older, I feel less of a need to impress, and more of a need to just ask questions, then listen to the answers. I think God has set me free of some serious pride, or insecurity. Probably both.

So at one point, I looked at Frank and asked, "What's the most important thing my generation needs to understand about leading people?" He talked for a moment about the importance of integrity – faith, actions, and more. Then he said this...

A leader doesn't always have to be right in order to move an organization forward.

He went on to say that many leaders he's seen over his seventy-plus years have always needed to be right. To be correct. He said that many leaders go to the wall over anything, and call it "vision". His assessment was this didn't need to be the case. His recommendation is that the only things worth going to the wall over were matters of faith.

I'll let you assess your own leadership under this magnifying glass.

But honestly – have you ever gone in a direction you thought wasn't the right direction, and achieved some measure of success at the end? I've

been wrong more times than I've been right, and God works in spite of me. Frank would not only encourage us to be open to that.

He'd also tell us to get over ourselves, and cease our pitiful incessant need to always be correct.

Thank God for accidental encounters like this one.

Thank God for the artists who are under our covering.

And thank God for pancakes with perfectly cooked bacon.

LEADERS WHO SEE

Seems like every leadership book I picked up in the late 90's worked at defining what true leadership was. And it seems like their definitions always came down to one thing.

True leadership was influence. Nothing more. Nothing less.

I disagree. A definition like that always assumes that the leader has the answer, or the way, or the vision figured out. It further assumes that all a leader needs to do is to inspire the people around him to catch on, and follow. Most leaders tell the story of Nehemiah rebuilding the wall as a perfect example of this.

Influence may be a byproduct of good leadership, but I don't think it's ever the core definition. Leaders may have influence, but influence isn't the end game. I think that true leadership is all about seeing.

Leaders see.

Over and over, leaders seem to see two things.

LEADERS SEE WHAT GOD IS DOING

A pastor sees that God is more interested in deep relationships than in growing the next mega-church. A father sees that God wants His children to get involved in a ministry that visits elderly people. A wife sees that God longs to heal her husband of his own father wounds. An artist sees that God wants her to donate a portion of her freelance income to clean water.

LEADERS HELP OTHERS JOIN GOD

It's one thing to stand at a distance, and observe what God is doing. But a real leader will always help people around her become practically involved in the very thing God is doing in the world.

Leaders see.

And they help others see too.

This definition of leadership flies in the face of that leader who's trying to build his own kingdom, based on his ability to speak publicly, or fund-raise privately. We already know this in our hearts, because we're put off by leaders who appear to be building their own kingdoms, and calling it "a move of God".

So think about the people who have exhibited authentic leadership in your life. In my world, there's always someone saying, "Gary. Look at what God's doing over there". Then, these men and women give me practical ways of joining Him in that location, with those people.

INSANITY

We can't really kill the dreams God has given us. We can, however, cause them to need life-support by constantly suppressing them. And nothing suppresses those dreams like continuing the same plan, but expecting different results.

Day after day after long day, this pattern is so easy for leaders to accidentally slip into.

We advertise the same way we did last year, because someone told us that a certain online method is the most effective.

We conduct our staff meetings the same way, on the same day, at the same time, and expect a more motivated staff team.

We even approach spirituality the same way, using methods that worked for us when we were at a high school church camp, but that cannot possibly work now.

Insanity is doing things the same way over and over again, but expecting different results.

When a leader engages in this, he runs straight into a brick wall, head first. Each time, he thinks the wall will fall down. But each time, his forehead gets a little more bruised, even a little more bloodied. What he needs to try is a different strategy – maybe climbing over the wall, or going around the wall, or hiring a demolition team to get rid of the wall.

I wonder how many good men and women have lost the ability to dream because their heads are simply too battered and bruised to see past the wall?

CODE

When I'm listening to people these days, I find myself listening for code words. When these code words pop up, it's really important to lean in and listen to what they're saying. If you're someone who has the privilege of leading artists, please understand that they are discovering safe ways to tell you their deepest needs, without acting like it.

Statement - "People need more intimate encounters with God."

Translation - "I need more intimate encounters with God."

Statement - "People need to feel more appreciated at work."

Translation - "I don't feel appreciated at work."

Statement - "People need to feel hope in this economy."

Translation - "I feel hopeless in this economy."

You get the idea.

This is true for bosses and employees and husbands and wives and artists and pastors and secretaries. When it comes to understanding people, there's a consistent echo.

We've learned safe ways to communicate our deepest needs in ways that protect their unveiling.

And I'm not writing about this so you'll be smarter than they are, or have an unfair advantage over them. I'm suggesting that leaders really need to learn how to listen better to artists, because that's the best thing they can give to the people around them.

We must learn to not only listen to their words, but to also learn the art of listening to what their words reveal about their heart.

The same heart Christ died for.

SQUASHERS

I was sitting around a table with some amazing Idea Guys. Three of us were brainstorming creative ways to help a client move forward with a social media strategy. It was an informal and unplanned discussion around a table. Every idea seemed like a good one.

You've been there, right?

After thirty minutes of really good ideas, a fourth man sat down with us. We started to share some of our ideas with him.

And he began to shoot them down. Seriously – Wild Bill Hickok with a mouth.

"The potential market won't use that."

"How are we gonna fund that?"

"I'm not a fan of this social media stuff anyway."

The table died.

I think I mumbled something about needing some more coffee, and I never came back. My friend came and found me. He said, "That guy is a dream squasher."

Dream Squashers.

We've got them all around us. They're not bad people. Most of the time, they're just trying to help the rest of us arrive at the right idea by weeding out all the wrong ones. And they do this on our behalf. Nothing wrong with that.

I need Dream Squashers in my life.

But I think it goes crazy-wrong when a Dream Squasher is a part of any creative brainstorm team, especially in the initial phases of a project. There should never be a Dream Squasher invited to participate in the initial phases of any creative endeavor. The team needs people who inspire creativity, not people who squash it.

Churches and other organizations tend to automatically place Dream Squashers into their creative environments because they're either on the payroll, or we think they'll add reality to the Team. And when that happens, I've never seen any Creative Leader who is happy with that decision.

People who help the rest of us think through potential roadblocks and setbacks are extremely valuable to our organizations. They do have a place.

But it's not at the beginning of the creative process.

And the Team Leader's responsibility is to keep the room safe by keeping Wild Bill far away. My prayer is for the courage to keep the Squashers at bay.

And for our creative tables to be full of life.

WHEN SKILL SURPASSES CHARACTER

You know that artist, right?

Her singing voice is beautiful, but her arrogance is ugly.

His blog is deep, but his real life is shallow.

His public speaking can hold a large group in the palm of his hand, but he doesn't live out any of the truths privately that he teaches in the public square.

His short films are inspirational and amazing, but his wife knows he's married to those films, not to her.

These days, it's easier than ever for any artist to create a platform for himself, for herself. But the size of the platform doesn't always equal the size of the character. Platform only displays skill level, not heart condition.

Beware of the artist whose skill level surpasses their character.

Artists are exceptionally good at faking it. I am exceptionally good at faking it. The problem comes when we fake it ALL THE TIME. Christian leaders must be discerning when it comes to artists who talk the talk, but who don't walk the walk. In my experience, not only will these artists fall, but they'll try their best to take you with them.

One of my many mistakes in pastoral ministry was not confronting this type of artist quickly enough. I called it "grace". I've since come to understand that sometimes the most gracious act I could have provided them was a removal of their platform.

Our platforms should have a long maze of steps onto them, but a quick exit elevator off.

CONTROL FREAK

I was talking with a friend the other day who is extremely frustrated with his leadership level in his church. When he was hired, he was told that he would be the "Director" of an entire wing of the church's ministries. The Executive Staff Team promised my friend the chance to dream, and to create the overall vision for his ministry area.

Four years later he's frustrated, and is ready to quit.

I don't have to go into the tiny details because you already know them. He's feeling the long-term results of serving under an over-controlling boss. My friend was given real responsibility, but no real authority.

Responsibility without authority.

This church is about to lose a true man of God, who will have a huge impact on His world in the coming years. But his impact will be somewhere else.

Because he's been given responsibility without authority.

Leaders in any organization can be very small people. They can be so full of fear that they feel the need to control everything, especially the people they hire. They are anxious to add staff who will take a task-related weight off them personally, but are far less anxious to hire staff who have a huge dream for the Kingdom, and who are clamoring for an opportunity to live it out.

In my quiet moments, I envision a church, or a business, where the key job of the Key Leader is to fan into flame the unique dreams of the people under him or her. I see a leader who hires big people with big dreams. And the leader is big enough to constantly communicate, "That may not be the way I would do it, but I'll support you every step of the way. After all, I trust you."

Because a leader cannot give responsibility without also giving authority.

Every leader I know, especially the one typing these words, is scared. Scared to fail. Scared to let God down. Scared to let people down. Scared to leave humanity unaffected when they die.

The mark of a real leader is never the absence of fear, but the willingness to hand their fears over to a God who is both good, and sovereign.

One hundred times every day.

May God grant key leaders of Kingdom organizations the confidence to give the sacred blessing of authority to those around them. And may He show us that there really is no such thing as "our vision" anyway.

It's all His.

FINAL THOUGHTS

So that's really good news. You're finished reading this book. If your boss made this required reading, you can now sit with him and say things like, "Yes. Yes. I really enjoyed the guy who tinkled in church. Tons of application there."

I really do hope you enjoyed the book, and were challenged by it.

I really do hope that the promise I made at the beginning of the book came true for you. That together, we explored the unique and crazy and beautiful and insane intersection at that exact place where faith and creativity meet.

I really do hope you want to keep this conversation going. Please go to

GaryMo.com

to discover what I think is current in the ongoing faith and art conversation. I'm always writing more posts and offering more free stuff there.

But my greatest hope in all of this is simple. I hope and pray that you go create some art.

That you create it in response to God.

That you create it so the world sees a God who is unseen.

That you not worry about how widely it's distributed. Just worry that it's distributed somewhere.

Thank you for reading, for growing, for disagreeing, and for creating.

> *"For we are God's handiwork, created in Christ Jesus to do good works, which God prepared in advance for us to do."*
>
> (Ephesians 2:10 NIV)

I really believe that.

CONTRIBUTORS

I was honored to have some friends and colleagues write the Section Introductions in my book. At many times during this project, I felt like our roles should be reversed.

SCOTT McCLELLAN - Author, blogger, Echo Church Media Conference Director, and deeper thinker. Scott gave me my first shot at writing articles that were actually published, and was one of my strongest encouragers in the formation of this book.

Web: ScottLikes.com

Twitter: @scottmcclellan

JASON W. ROWE - Partner at Floodgate Creative, amazing designer, and the tattooed son I never had. At the beginning of every section introduction, the drawings were originally created for this book by Jason. I watched him draw each of them. Amazing.

Web: TheJRowe.com

Twitter: @thejrowe

JEFF PARKER - Vice President of the RT Group, writer, lover of sports. Jeff is wise beyond his years, and I regularly seek his wisdom on business issues. After my father passed, Jeff's constant IPhone communication helped walk me through a very dark and difficult time.

Web: IgniterMedia.com

Twitter: @jeffeparker

ROB W. THOMAS - Founder and President of the RT Group, big dreamer, full of grace and truth. Rob has provided me with an entrepreneurial big brother, and a safe place to express my deepest and most private feelings.

Web: IgniterMedia.com

Twitter: @robwthomas

CANDICE V. WILKINS - Candice is an old soul in a young body. She is strong and open - two characteristics not usually found in the same person. Candice has a heart to educate the world about human trafficking, and has the strength to succeed.

Web: TheChristineProject.org

Twitter: @CandiceWilkins5

DAVE WILKINS - Dave is the artsiest artist I know. He's also the most level-headed friend I have. Dave is not only a partner at Floodgate, but he is a partner for me in my life. He is one of my closest friends, and someone I deeply respect. Dave created the cover art for this book, and it's simply beautiful.

Web: MakeShiftMe.com

Twitter: @DaveWilkins5

KATIE STRANDLUND - At the time of this writing, I had never met Katie in person - only online. I have become captivated with her writings about the church. And the Church. She speaks with a voice that her generation desperately needs to hear.

Web: CautiousCreative.com

Twitter: @kstrandlund

PAT CALLAHAN - Most pastors I know are vocational pastors, trying to act normal. Pat is a normal person, trying to act like a vocational pastor. As a worship pastor, Pat creates amazing moments for thousands of people each week. As a leader, Pat creates amazing environments for artists to play in.

Web: about.me/patamo

Twitter: @patamo

CPSIA information can be obtained at www.ICGtesting.com
Printed in the USA

266066BV00004B/5/P

9 781449 718015